Domenico Laurenza

LEONARDO
ON FLIGHT

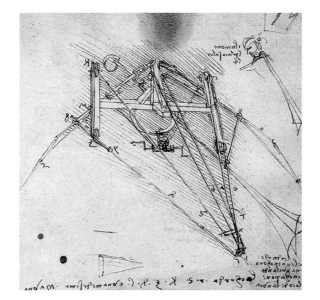

THE JOHNS HOPKINS UNIVERSITY PRESS
Baltimore

Leonardo's manuscripts and drawings, all available in the Edizione Nazionale Vinciana (Giunti), are found in the following locations (the letters in the first column correspond to the abbreviations in the text):

A Manuscript A (ca. 1490-1492), Paris, Institute de France
B Manuscript B (ca. 1487-1490), Paris, Institute de France
CA Codex Atlanticus (folios from various periods), Milan, Biblioteca Ambrosiana
CF III Codex Forster III (ca.1493-1496), London, Victoria and Albert Museum
CT Codex Trivulzianus (1487-1490), Milan, Castello Sforzesco, Biblioteca Trivulziana
CV Codex 'On the Flight of Birds' (ca. 1505), Turin, Biblioteca Reale
E Manuscript E (1513-1514), Paris, Institute de France
G Manuscript G (1510-1515), Paris, Institute de France
K¹ Manuscript K¹ (1503-1507), Paris, Institute de France
L Manuscript L (1497-1504) Paris, Institute de France
M Manuscript M (1495-1500), Paris, Institute de France
Md I Manuscript Madrid I (1490-1508), Madrid, Biblioteca Nacional, Manuscript no. 8937
W Windsor Castle, Royal Library (folios and manuscripts from various periods)

© 2004 Giunti Editore S.p.A., Florence-Milan

First published in the United States in 2007 by the Johns Hopkins University Press
Printed by Giunti Industrie Grafiche S.p.A. – Prato
9 8 7 6 5 4 3 2 1

The Johns Hopkins University Press
2715 North Charles Street
Baltimore, MD 21218-4363
www.press.jhu.edu

Library of Congress Control Number: 2007928520

ISBN 13: 978-0-8018-8766-6
ISBN 10: 0-8018-8766-6

Frontispiece: Study for the flying machine (B 75r, detail). Florence, Istituto e Museo di Storia della Scienza.
Page v: Experimental studies for the flying machine (B 88v, detail).

Concept and editorial co-ordinator: Claudio Pescio
Editor: Augusta Tosone
Translation: Joan M. Reifsnyder
Graphic design and layout consultants: Edimedia Sas, via Orcagna 66, Florence
Cover Design: Renata Silveira and Paola Zacchini

CONTENTS

7

The Origins of an Idea

31

Force Diagrams

63

Nature in the Foreground

91

The Primacy of Theory

118

Bibliography

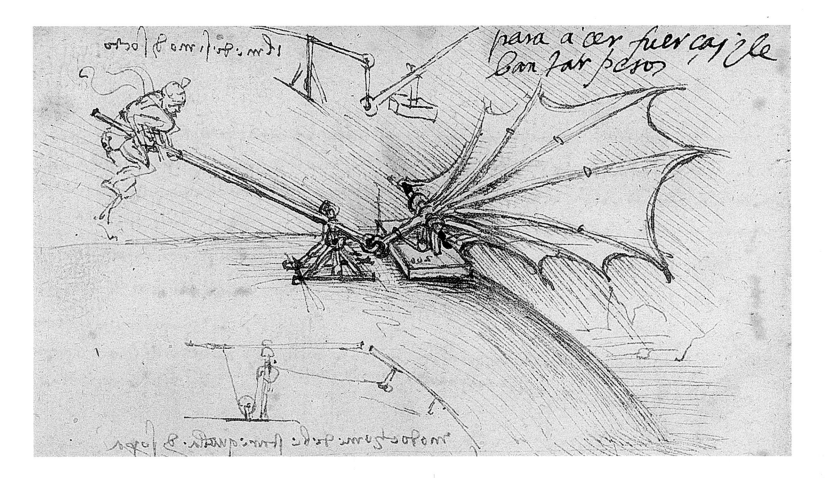

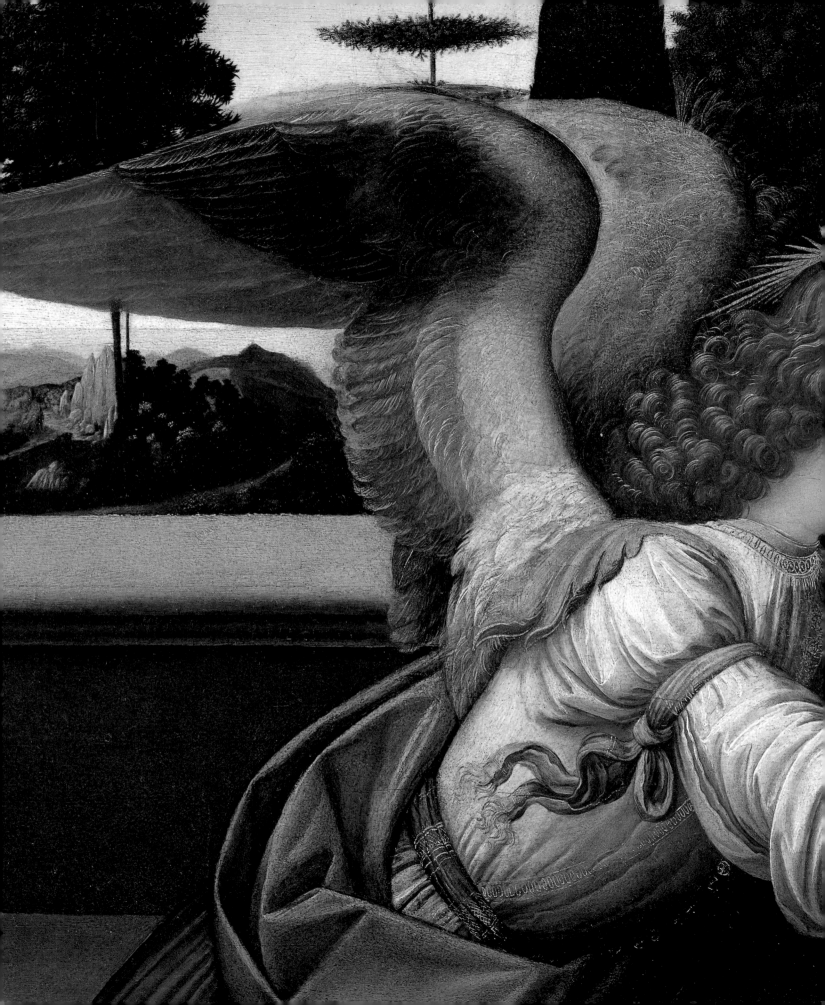

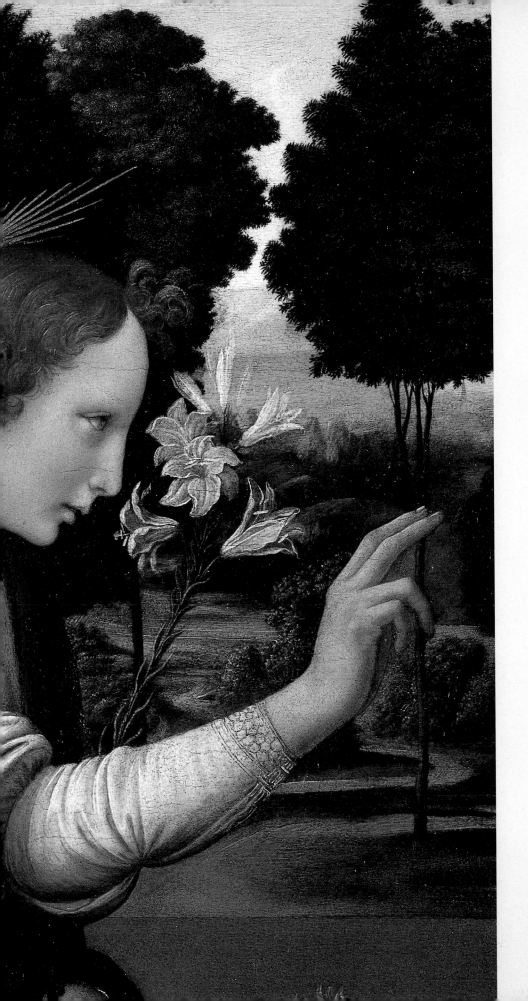

The Origins of an Idea

Florence
ca. 1469 - 1482

The idea of a flying machine, capable of fulfilling one of man's wildest dreams, seems to originate from stimuli received during Leonardo's formative years in Florence. The young genius came in contact with the longstanding Florentine tradition of theatrical machinery while in the workshop of Andrea del Verrocchio. Among the 'special effects' used during performances to astonish and captivate audiences, were all types of flying contraptions. There was also Leonardo's passion for the animal kingdom, and most importantly, his studies on the flight of birds. Winged dragons and other types of fantastical creatures were often among the subjects clamoured for in Florentine art of the time. Finally, there were the early studies by fifteenth-century Sienese engineers and their designs for innovative machines that would be among the first to challenge human limits.

Preceding pages: detail of the angel in the Annunciation (Florence, Uffizi, ca. 1472-1474).

1 and 4 Two Annunciations (Florence, Uffizi, ca. 1472-1474, and below, Paris, Louvre, 1478-1482, the latter only in part by Leonardo).

2 Study for a Nativity surmounted by flying angels (ca. 1480; Venice, Accademia no. 256).

3 and 5 Santa Maria del Fiore with Brunelleschi's dome and a model of a slewing crane used on the Brunelleschi work site. The model is based on a drawing by Leonardo, who like other engineers, studied Brunelleschi's machines (Florence, Istituto e Museo di Storia della Scienza).

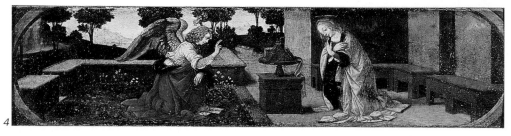

1

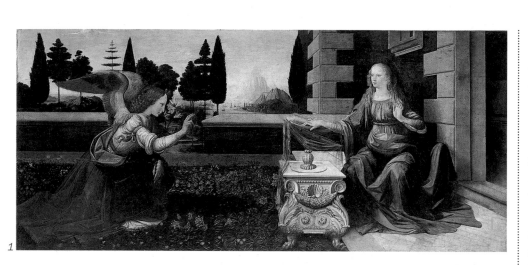

2

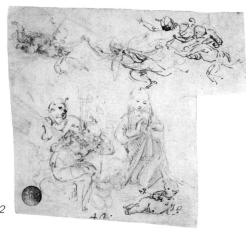

3

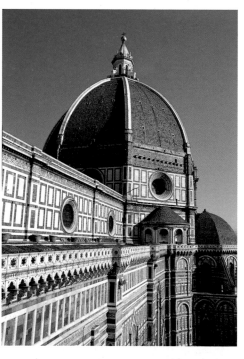

4

THEATRICAL MACHINES

In about 1469, Leonardo left his native town of Vinci for Florence to train in the workshop of Andrea del Verrocchio. Not only did the workshop produce sublime paintings and sculptures (figs. 4, 16, 26), but as in many of the famous Florentine *botteghe* of that time, a vast array of objects were manufactured; objects ranging from weapons to church bells. Among the various workshop activities was the construction of sets and scenery used for festivals and theatrical performances, both pious and profane in subject matter.

In addition to the acting, an important part of the performance was the movement and change of the scenery. To accomplish the scene changes, complex theatrical machinery called *ingegni* were used (from the Latin *ingenium*, a natural disposition or talent, and basis of our word, engineer). The audience found themselves in front of truly 'living paintings', where even the actors were dominated by the movement of the sets and scenery, ingenious contrivances from the Florentine workshops.

In 1439, Abraham the Bishop of Soudzal was in Florence, and the notes he made at the time give very detailed descriptions of the performances he attended. He tells of his wonder and marvel when at a certain point during the representation of the *Ascension*, 'the sky opens and the Heavenly Father appears, miraculously suspended in air' while 'the actor playing Jesus seems to have truly ascended on his own; and without tottering, reached a great

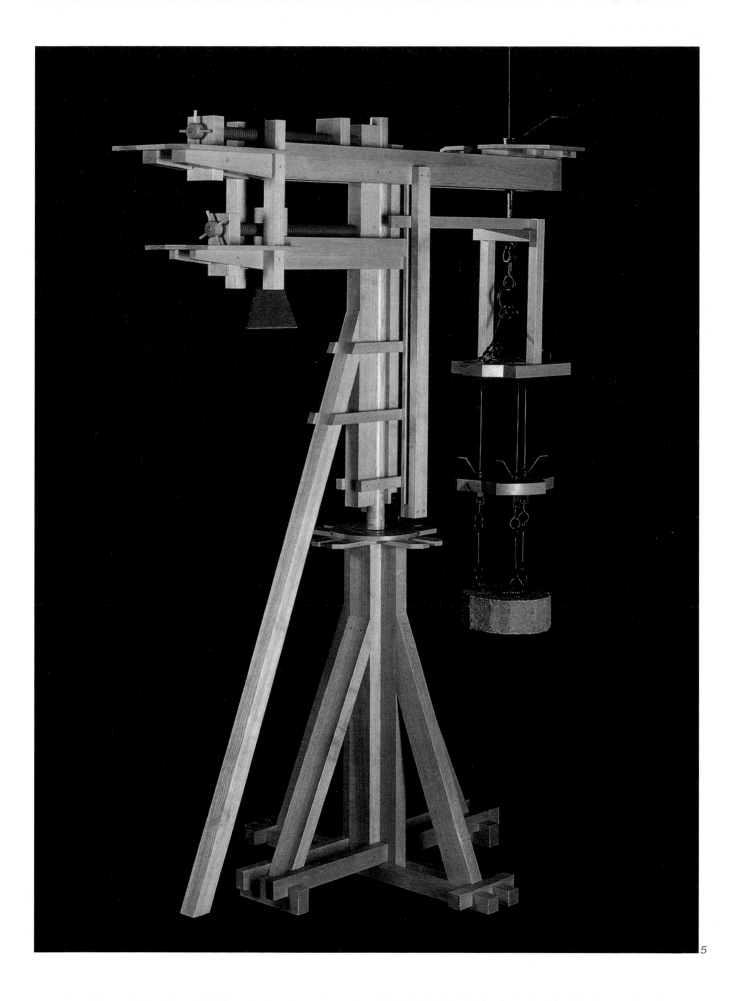

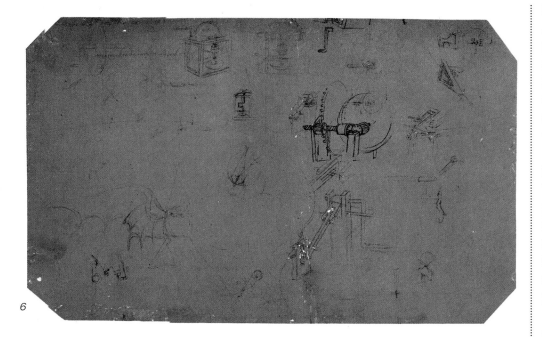

6

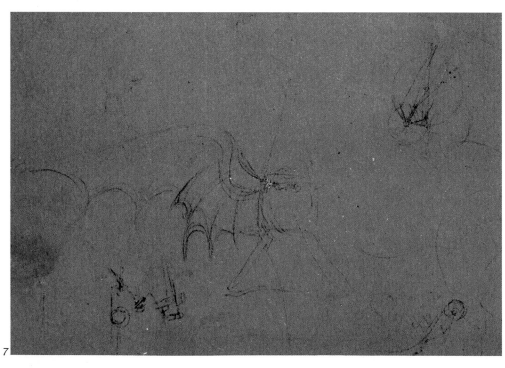

7

height'. In the church of Santissima Annunziata, the *Annunciation* was presented, and the Russian bishop commented on the stage effects: 'as the angel ascends amongst the voices of jubilation, he moves his hands up and down, and flaps his wings as if he were truly flying'.

In March of 1471, Florence was visited by Duke Galeazzo Maria Sforza. Verrocchio also participated in the preparations that were underway for the celebrations honouring the Milanese Duke. During the Lenten period, festivities could not be overly elaborate. Nonetheless, religious plays were presented.

The *Annunciation* was staged in the church of San Felice in Piazza, on the Oltrarno a short distance from the Ponte Vecchio; the *Ascension* was presented in the church of the Carmine, and not far from there, in the church of Santo Spirito, the *Pentecost* was performed.

These three dramatisations, performed in honour of Duke Sforza's presence in Florence, had already been presented many times in previous years, and the general emphasis must have been on the simulation of vertical ascent and flight. In the *Ascension*, there were angels suspended over clouds who descended and then accompanied Christ up into heaven. In the *Annunciation* in San Felice, Archangel Gabriel descended from the heavens in a *mandorla* from which other angels were hanging.

All these contrivances and figures were supported and put in motion using cables and motorised-mechanical

devices. The leading artist-engineers of the time dedicated themselves to inventing and creating these machines. Most likely, the production of the *Annunciation* viewed by Duke Galeazzo in 1471 was still based on the use of the *ingegni* perfected during the first half of the century by the greatest Florentine architect of the Renaissance: Filippo Brunelleschi (figs. 3, 5).

This is the world in which young Leonardo is immersed: Florentine workshops capable of producing not only artistic masterpieces, but marvellous machines as well. And it is probably in this environment that the seeds of the idea to imitate birds using a flying machine germinate in Leonardo.

It is more than likely that this idea is born right in Florence, during Leonardo's formative years, and not, as scholars have at times hypothesised, after his move to Milan in 1482-1483. A folio in the Uffizi (no. 447 Ev; fig. 6) dating from Leonardo's younger years clearly shows a figure in the lower left with bat wings (only one of the two wings is completely drawn). Immediately to the right, a mechanical device for a larger wing (fig. 9) is drawn, while there is the hint of another wing, connected to a bar, sketched in the upper right (fig. 10). These sketches all refer to a machine with flapping wings: a flying machine. But with a very specific purpose.

In the drawing of the figure with bat wings (fig. 7), there is a head, a chest and what could be a tail (or an angel's tunic). There are also two triangular structures that converge on the top and the bottom into what seem to be cables

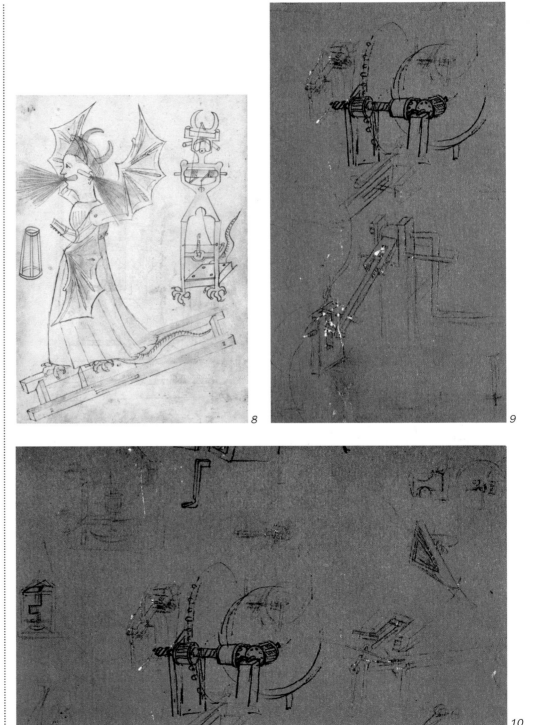

8

9

10

11-15 Devices
for machines
with flapping wings,
perhaps
for theatrical use.
In the centre of
fig. 12 and fig. 14.

The machine
is in the form
of a boat
(ca. 1480;
CA 991r, 156r,
144r, 860r, 858r).

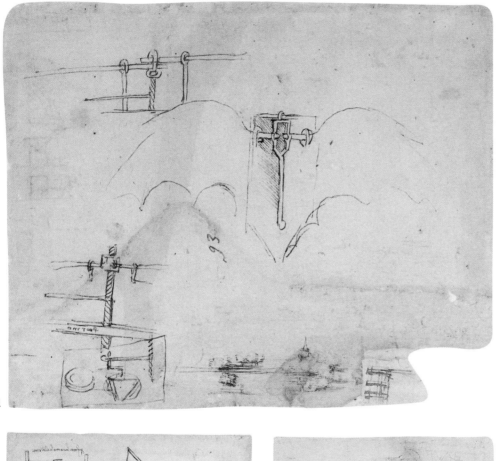

11

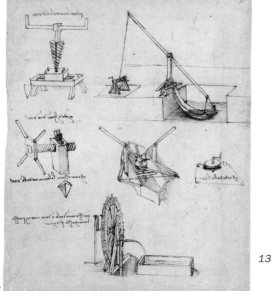

12

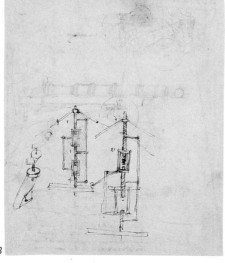

13

or suspension devices. The upper apex of the triangle continues as a clearly visible cable, inserted through an overhead pulley.

Based on this reading, the sketch is not simply a generic study for a flying machine, like the ones Leonardo did in later years, but the design for an *ingegno*, an angel or a demonic animal that was supposed to 'fly' suspended from a cable during a performance. Dramatic productions with similar characters were, in fact, well documented in Florence. An example of this was made for the 1454 feast of St. John the Baptist. Parading through the streets of Florence, one of the allegorical carts depicted Michael the Archangel battling with Lucifer. At a certain point, the cart stopped and the performance of the battle between the angels began. The scene ended with the expulsion of Lucifer and his army of the damned from heaven. Another great *Quattrocento* engineer, Giovanni Fontana (1393-1455) in his *Bellicorum Instrumentorum Liber*, designs automatons with membrane-covered wings for festivals and dramatic productions (fig. 8).

The peculiar motorised-mechanical device in one of the previously mentioned drawings was probably also destined for use in theatrical productions (fig. 9). It consists of a wing connected to a hand-crank with a range limited by a bracket, and therefore, the resulting alternating movement was not capable of transmitting a sufficient flapping action to the wing to lift it off the ground and put the device in flight. Most likely, Leonardo does not mean to send the

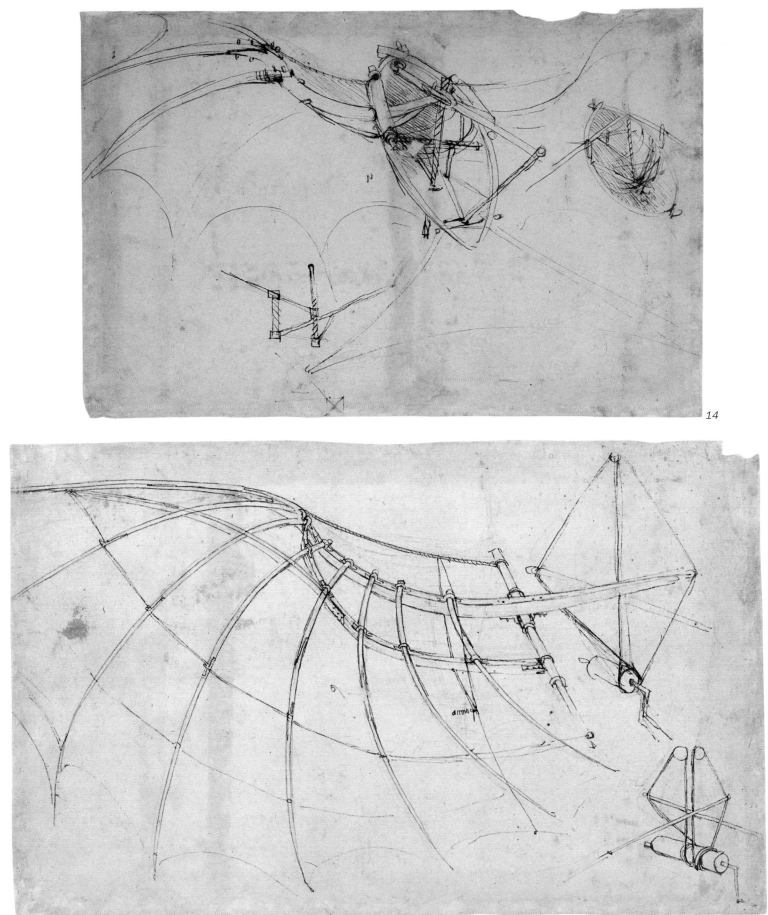

14

15

16 Leonardo and Verrocchio's workshop, study for a jousting banner (ca. 1475; Florence, Uffizi, drawing no. 212E).

17 Devices for theatrical presentations: acoustic amplifier (top right) and (immediately below) a device for lifting an automaton (ca. 1478-1480; CA 75r).

18 and 20 Studies for lanterns (top left in fig. 18; ca. 1480; CA 34r and 576av, detail).

19 Flying machine perhaps destined for the theatre (Oxford, Ashmolean Museum, detail).

21 Line depicting the flight path of birds, on another side of the folio (fig. 6) with the studies for a theatrical flying machine (ca. 1480; Florence, Uffizi, no. 447Er, detail).

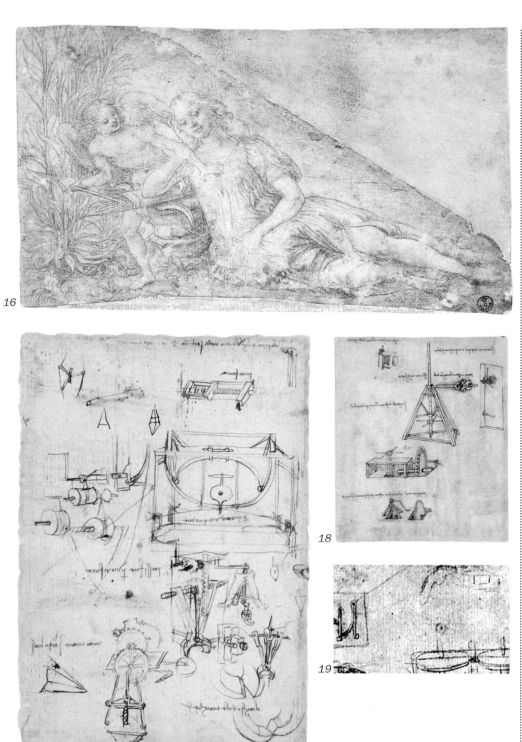

16

17

18

19

device in flight, but simply to create a flapping motion in order to animate the scene. A similar device consisting of a square platform supporting struts to which wings are connected is also sketched on a folio in Oxford (fig. 19). In this case however, there are two wings on each side.

It is probable that this aspect of Leonardo's research, reproducing the movements of wings – not for flight – but to marvel the audiences during a theatrical performance, includes the studies made in about 1480 during his formative years (figs. 11-15 and 34). In all these studies, the motion of the wings is based on the principle of multiples; by alternating the movement of the hand to the left and to the right, a crank connected to a central, vertical screw translates the motion into an up-and-down movement, thus flapping the wings. Like the crank on the Uffizi folio, the movement in the wings is limited, and, therefore not conducive to flight. In fact, this mechanism does not appear in the subsequent studies dedicated to actual flying machines. The centre screw passing centrally through the machine itself, extends both above and below the device, implying that it also served as a suspension cable. Two drawings (figs. 12 and 14) illustrate a central form shaped like a boat's hull, and one of these drawings (fig. 14) is flanked by enormous, membrane-covered wings and a huge tail, again, indicating its use in theatrical stage settings.

Leonardo's interest in the theatre and stage machinery dates from about the

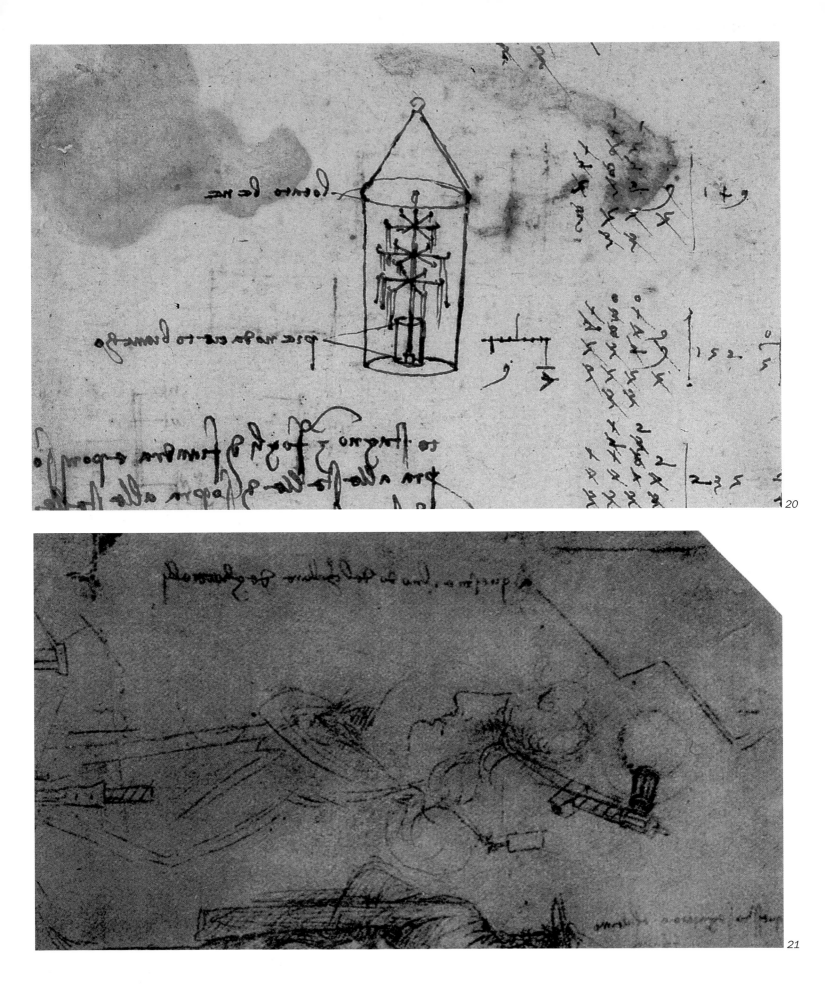

20

21

22-24 and 25-26 Two versions of Saint George and the Dragon by Paolo Uccello (1465, Paris, Musée Jacquemart-André and ca. 1470, London, National Gallery), a drawing by Leonardo

(ca. 1480; W 12370r), marble basin attributed to Verrocchio (Florence, Sacristy of San Lorenzo): examples of the frequent presence of winged-creatures in Florentine art of the Quattrocento.

23 On the other side of the folio with studies for a flying machine (fig. 6), Leonardo studies the descending flight path of birds (top left); from the world of theatrical machines

Leonardo's mind passes to the study of nature (ca. 1480; Florence, Uffizi, no. 447Er).

22

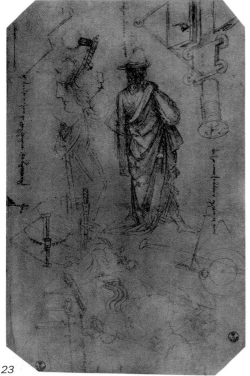

23

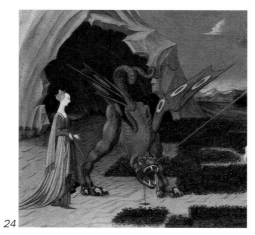

24

time of his first sojourn in Milan. Even during the first few years in Florence, however, there are other signs of his interest and involvement in theatrical productions.

While young Leonardo was working for Verrocchio, he probably took part in the realisation of a tournament banner, as the drawing from the Uffizi (no. 212E; fig. 16) would illustrate. In a folio from the Codex Atlanticus (75r; fig. 17) there is a machine (the main drawing in the upper right), used for 'generating a big voice', something certainly useful in a theatrical representation.

Directly below, there is the sketch of a screw with a hook on the end, worked with a handle that passes through the lower part of a human body, complete with legs and wearing two long stockings. Clearly a theatrical *ingegno*. On the reverse side of the folio, the partial notation appears: 'To project a large light', and it seems to deal with the problem of 'lights', useful for the theatre. This same problem is taken up again in other notations and drawings depicting lanterns (CA 34r and 576av; figs. 18 and 20), and dating from the same period. In this latter (576av) the notation 'put above the stars', appears to confirm its use in a theatrical setting.

STUDIES OF THE ANIMAL WORLD

Everything we have discussed to this point, or almost everything, is part of the normal knowledge and activity of the *Quattrocento* Florentine artist-engineer. However, Leonardo goes well beyond this level because his flying

machine project was closely connected to his intense study of the animal kingdom.

On the reverse of the Uffizi folio, Leonardo notes: 'This is the manner in which birds descend' and next to it, he outlines the path they follow (figs. 21 and 23). An isolated notation, a quick sketch; nevertheless, important clues as to how Leonardo reaches beyond the limits of inventing for theatrical machinery. Even if Leonardo's design of a mechanical device capable of reproducing the movement of flapping wings only visually imitates nature and is used in a theatrical representation, it is closely tied to his observations of birds in flight. We are face-to-face with the first hint of what will become the hallmark of Leonardo's studies on flight: the 're-making' of nature, re-creating natural flight after having grasped its inner-most workings.

In his biography on Leonardo in the *Lives of the Most Eminent Painters, Sculptors, and Architects*, Giorgio Vasari mentions a Medusa's head, an early, lost work by the young artist. The influential notary, ser Piero, Leonardo's father, requested his son to paint the image on a piece of wood for one of his peasants. Leonardo is still immersed in the splendid Vinci countryside, and Vasari narrates that in order to design the image, 'he secretly brought into his room a variety of lizards, crickets, butterflies, locusts, bats, and various strange creatures of this nature; from all these creatures he took and assembled different parts to create a fearsome and horrible monster'.

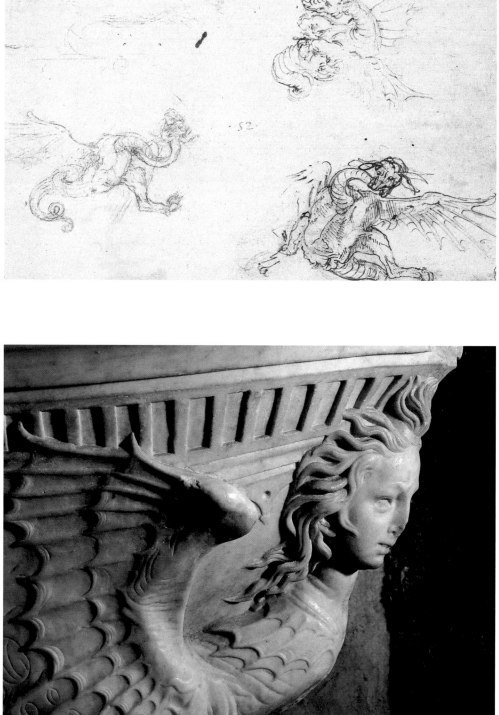

25

26

27-29 Studies for
a flying machine
zoological studies
for a dragonfly
and another
flying insect
(ca. 1480-1485;
CA 1051v, full view
and details).

27

28

This story is nothing more than a legend, however it demonstrates Leonardo's interest in zoology. It is in the iconographical context of bizarre animals such as winged dragons, reoccurring in Florentine art of the time (figs. 22, 24, 26) that Leonardo's interest in human flight is nurtured.

In fact, on the reverse of the Uffizi folio, a dragon with the wings barely sketched in, can be clearly seen (fig. 23). Another drawing dating from the same period depicts a battle scene with a dragon having membrane-covered wings like those on the winged machine drawn on the front of the same folio (W 12370r; fig. 25).

A folio from the Codex Atlanticus (1051v; figs. 27-28) reveals other traces of this early relationship between studies in zoology and flying machines. Perhaps Leonardo worked on this folio shortly before leaving Florence or soon after his arrival in Milan. Among the drawings on this folio, there are the sketches of two small animals similar to those, which according to Vasari, captivated young Leonardo in the countryside around Vinci: a dragonfly and a four-winged flying insect. A lengthy note in the margin is an invitation or a reminder to himself: 'To see four-winged flight, go around the ditches and you will see the black net-wings'. Even the faint sketch at the centre of the Uffizi folio (immediately above the large wing; fig. 6) is probably meant to depict a two-winged insect or other similar insect. As already mentioned, even the sketch for the flying machine on the Oxford folio (fig. 19) has two wings on

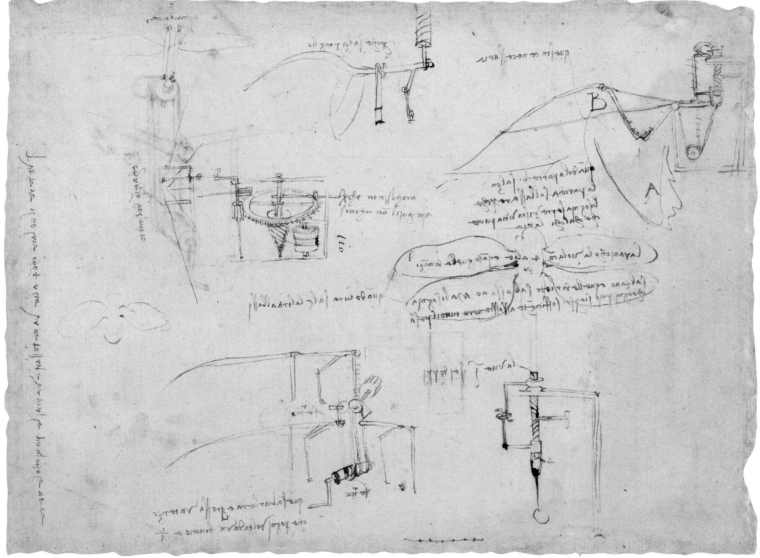

29

*30-33 Mechanical
devices based
on water: hoisting
water (top and left
in fig. 30 and
fig. 33), measuring
the weight
of a waterfall
(fig. 31),*

*transformation
of water into vapour
(fig. 32)
(ca. 1480; CA 19r,
full view and detail;
1112v, detail; 26v).*

30

31

32

each side, like those on the dragonfly. In the Codex Atlanticus folio, the connection between zoological research and the design for the flying machine is even more evident. From a zoological standpoint, the dragonfly fascinates Leonardo because – as he believes – the beat of the four wings alternates: when the front pair go up, the back pair go down. (Above the drawing of the dragonfly, Leonardo writes: 'The *pannicola* flies with four wings and when the front ones are raised, the rear ones are lowered. But each pair must in itself be sufficient to sustain the full weight'. Next to this, connected by two lines to the wings: 'When one goes up the other goes down'.) Thus, when the pair of wings is raised, ready to flap downward, the other pair, in the lowered position, provides the surface support that keeps the insect in flight.

Later on, Leonardo's interest in natural flight will be further developed. However the observation of natural flight provides Leonardo with a clearer idea of artificial flight and is based on the design for a machine that should truly support itself and move in flight. In fact, on the same folio in the upper right (figs. 27, 29), there is the study for a mechanical wing. Even though it is a single wing, it is comprised of two sections – A and B – imitating the alternating movement of the two pairs of dragonfly wings: when the front part B goes up, the back part A is lowered pressing the air down ('When part B goes up, part A has to go down, because there always has to be a part that is pressing down on the air').

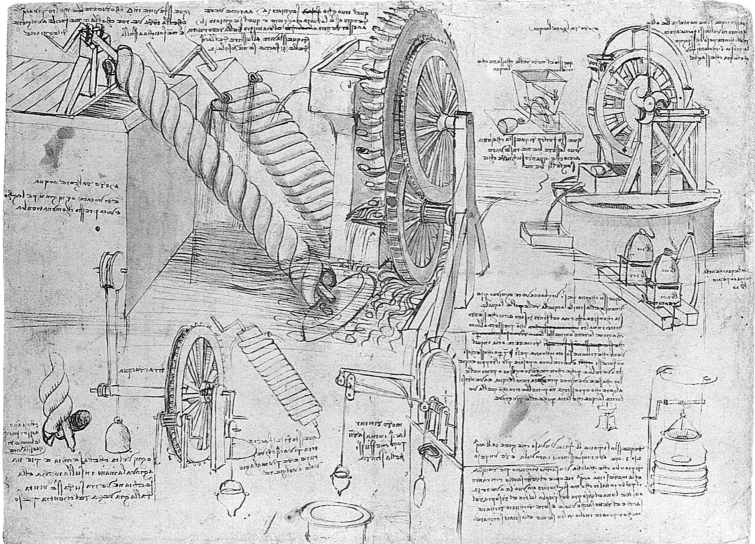

33

34 Studies for
 a flying machine
 (ca. 1480;
 CA 1059v).

35-36 Hygroscopes
 used as devices
 in studying the air
 (ca. 1478-1480;
 CA 30v, detail
 and Louvre
 no. 2022, the centre
 top drawing).

34

35

TECHNICAL 'MIRABILIA'

Leonardo's studies of the animal world together with his project for a machine capable of simulating natural flight, is only one example of how he transcends the workshop activities of theatrical *ingegni*. In fact, part of the engineering projects and designs carried out by Leonardo while he is in Florence involve the natural elements and the physical study of water, earth, air and fire. For example, Leonardo studied various means for hoisting water to an elevated level (CA 19r, 26v; figs. 30 and 33), for transforming water into water vapour (for example, CA 1112v; fig. 32), for calculating the 'weight' of a waterfall (CA 19r, 'how to weigh falling water'; figs. 30 and 31).

The study of air was treated in an analogous process. One of his two drawing for hygroscopes (CA 30v, and Louvre no. 2022; figs. 35 and 36), from about 1478, is accompanied by the note: 'How to weigh air and know when the weather will change'. The device consists of a balance rod holding a sponge to absorb the humidity on one end, and on the other, a piece of wax, which will not absorb water. The humidity absorbed by the sponge lowers that side, thereby indicating the 'weight' of the air and the humidity, an element which for Leonardo, was an integral part of the air. These two hygroscopes do not appear in relation to his studies on flight but they do show up in studies carried out at a later time (for example, the hygroscope in the Codex Atlanticus, folio 675r).

An important document relating to

37 Plumb-line device, an instrument for measuring angles, (17th century; Florence, Istituto e Museo di Storia della Scienza).

38 Mariano di Iacopo, called Il Taccola (1382-1458?), device for excavating tunnels, another example of the ambitious projects by Tuscan engineers during the Quattrocento (Florence, Biblioteca Nazionale, Ms. Palatino 766, f. 33r).

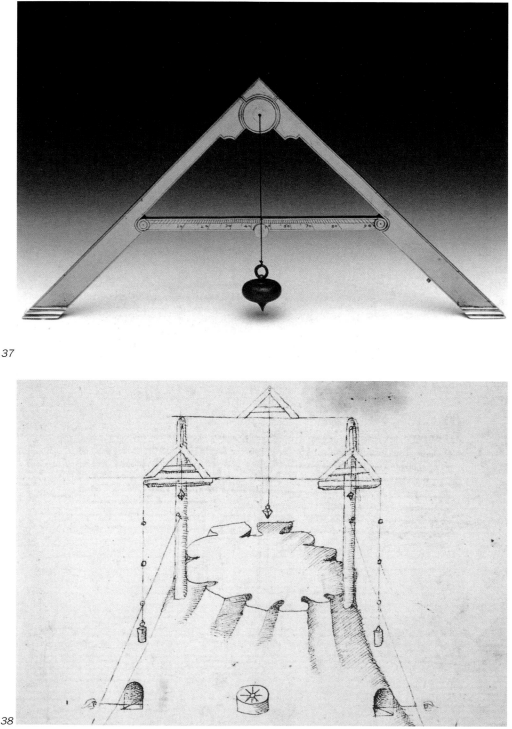

37

38

Leonardo's early activity as engineer and inventor is his letter of introduction to Duke Ludovico il Moro, dating from just before or just after his move from Florence to Milan in 1482-1483. The letter is not in his handwriting, but was almost certainly the work of a 'man of letters' who 'latinized' Leonardo's words.

In this letter, Leonardo extols his technical abilities as unprecedented and extraordinary. He goes on to say that these abilities may even appear impossible or unfeasible to some people. At the beginning of the letter, Leonardo prefaces his various undertakings as 'secrets of mine', a reference to the culture of 'secrets' and technical 'mirabilia' having a long tradition going back to the Middle Ages.

At the height if the thirteenth century, Roger Bacon, a famous natural philosopher (during this era, the scientist as we know him today did not exist, but instead there was the natural philosopher: science and medicine, being branches of philosophy) lists a series of marvellous inventions in *Epistola de Secretis Operibus Artis et Naturae*: ships capable of plowing through the seas and rivers without oars and rowers; carts and wagons that could move without animal power; devices used to walk on water and to move underneath the water, and even contrivances capable of putting man in flight, having a person placed in the centre of a mechanical device with artificial wings.

Ambitious in tone, this list recalls precisely the letter sent by Leonardo

THE LETTER IN WHICH LEONARDO INTRODUCES HIMSELF TO LUDOVICO IL MORO

"Having, my most illustrious Lord, seen and sufficiently considered the proofs of all those who call themselves masters and makers of the instruments of war, and seen that the concepts and operation of said instruments are in no way different from those in common use, I personally will try to explain to Your Excellency, my secrets […]. I have ways to make bridges that are extremely lightweight and strong, and easy to carry […]. And when at sea, I have many suitable ways for attacking and defending, and ships […]. Item, I have methods, by secret and distorted ways and without making any noise, of reaching a designated point, even should it be necessary to pass under ditches or a river. Item, I will make wagons that are covered, secure and which can not be attacked […]. In peacetime I believe myself to be equal to any one in architecture […]. Item, I can accomplish in sculpture […] as well as painting, whatever anyone else can do, whoever he may be. Further, work could be begun on the bronze horse, to the immortal glory and eternal honour of the happy memory of the Lord your father […]. And if any of these things mentioned above should appear to some impossible or unfeasible, I will offer myself ready to demonstrate them in your park or any other place your Excellency may desire". (CA 1082, at one time 391ar).

Below left, the folio from the Codex Atlanticus containing the letter in which Leonardo presents himself to Ludovico il Moro (right, Duke Ludovico in a detail from the Pala Sforzesca, *painted by an unknown Lombard artist during the late Fifteenth century; Milan, Brera). The letter was written for Leonardo by a 'man of letters' and for the most part makes reference to war devices.*

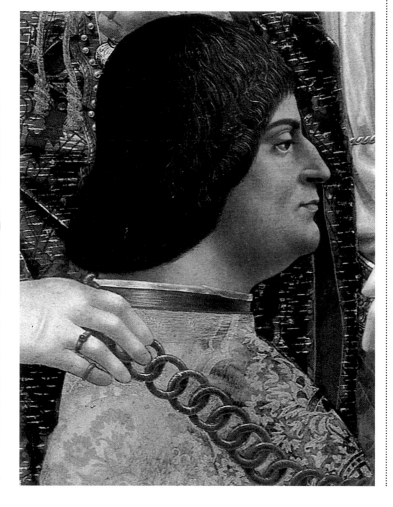

39-40 Anonymous
Sienese engineer
from the 15th
century, two
studies for
parachutes
(London, British
Library, Ms. Add.
34113, ff. 189v
and 200v).

39

to Ludovico il Moro. Nonetheless, Leonardo does not mention a flying machine in his letter.

This is probably because a flying machine did not seem have any practical use. Hoping to be engaged as engineer and artist, in presenting himself to il Moro, Leonardo stressed the practical aspects of his abilities: certainly his inventions are marvellous and almost miraculous, but he has to show the Duke of Milan how they can be put to practical use in military undertakings or in civil engineering, two areas of activities necessary to the Milanese Duchy (war and hydraulics). At the end of his letter, Leonardo even extols his artistic capabilities making reference to the creation of a monument to Francesco Sforza, il Moro's father.

For the engineers and inventors during Leonardo's time, the technological 'dreams' described at the height of the Middle Ages by Roger Bacon were more than at the forefront of the day.

Leonardo owed a great deal to the *Quattrocento* Sienese engineers, who were fully occupied contriving devices to improve man's navigation, both above and below the sea, to move quickly over land and to excavate subterranean tunnels (fig. 38). These engineers dealt with man's movement through air on at least two occasions, proposing a parachute and two very unlikely wings (figs. 39 and 40; British Library, Ms. Add. 34113, ff. 189v and 200v).

In his letter to Duke Ludovico, Leonardo mentions both navigation and tunnelling under the ground. In his ear-

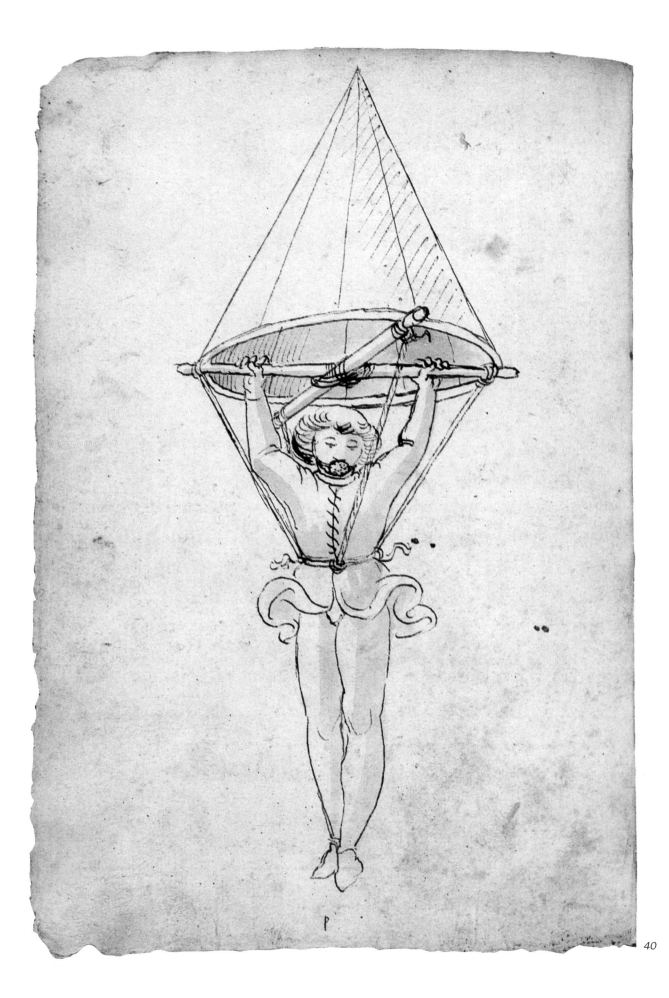

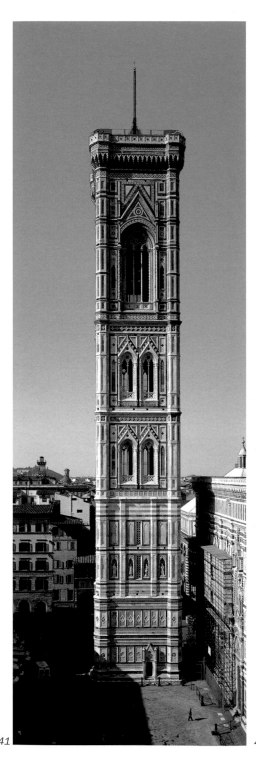

41

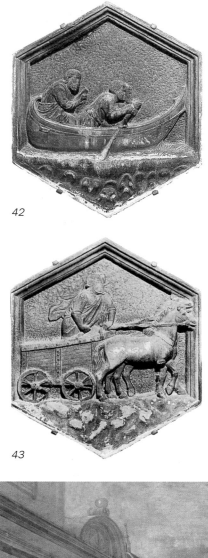

42

43

44

ly studies, Leonardo even designs a flying machine in the form of a boat (CA 156r and 860r; figs. 12 and 14). Flight is the ultimate challenge, the new and audacious art. Nonetheless, it can only be imagined using scientific thought based on analogy: if man, like fish, is capable of swimming underwater, he can, like the birds, soar through the air.

In the mid-fourteenth century in Florence a series of sculpted panels decorated the lower portion of Giotto's Bell Tower (fig. 41) next to the cathedral of Santa Maria del Fiore. The general theme was the Creation of Man and the Mechanical and Liberal Arts (figs. 42, 43, 45). Among these panels is one representing navigation (fig. 42) and another depicting the myth of Daedalus, a clear allusion to man's desire to fly (fig. 45).

Almost a century later, the most important artistic and engineering undertaking of the Florentine *Quattrocento*, Brunelleschi's dome for Santa Maria del Fiore, will stand out beside the sculpted panels on the Bell Tower. These panels serve as a manifest for the seething cultural environment between the fourteenth and fifteenth centuries, which in Tuscany was more than ever dominated by the artist-engineer.

In this very creative atmosphere, the challenge of human flight as seen on the bell-tower panel by Andrea Pisano and by the efforts of the Sienese engineers is already in the making. Leonardo accepts this challenge and propels it to its extremes.

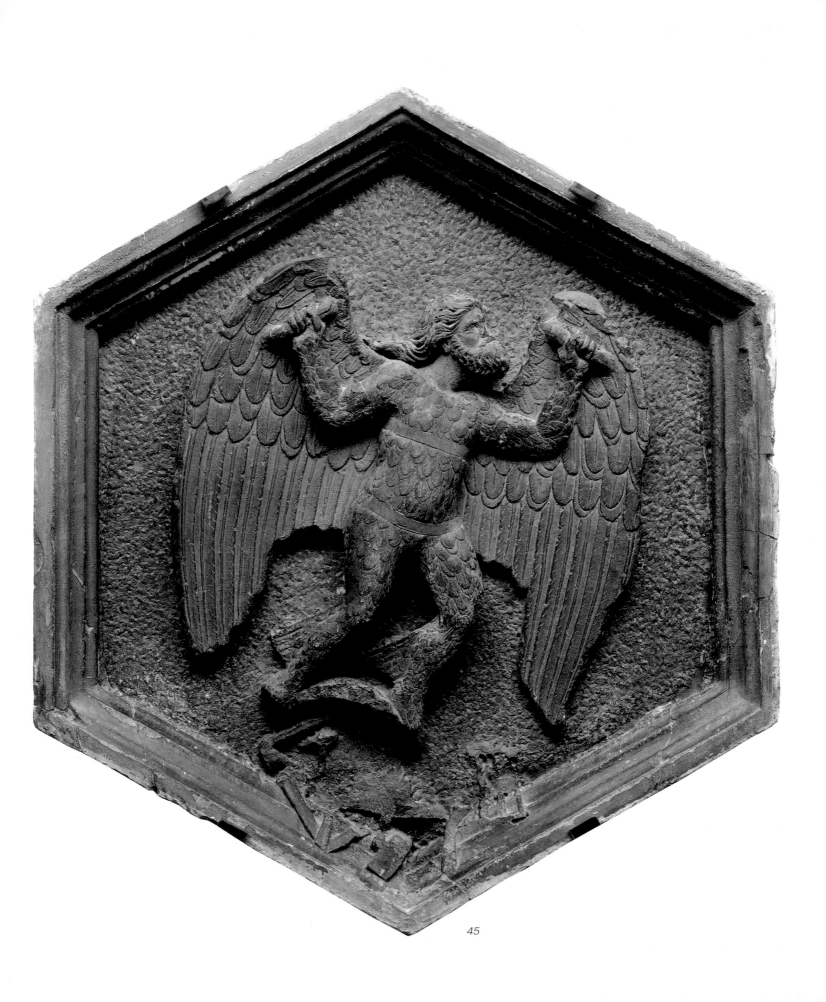

45

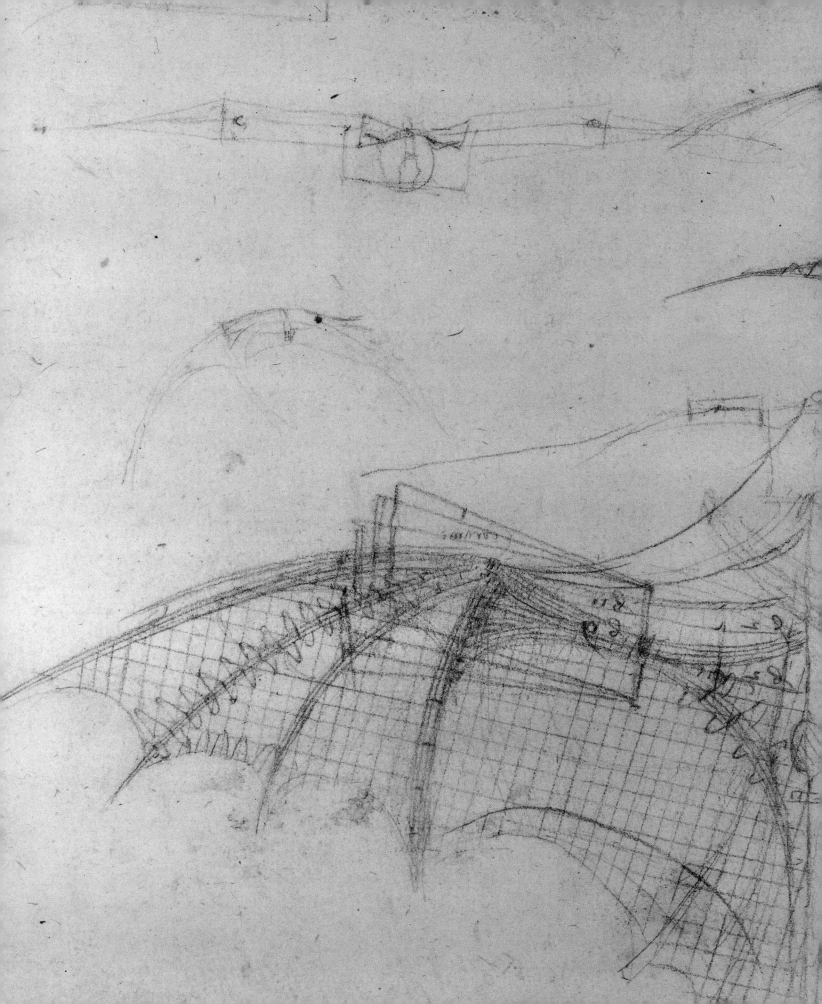

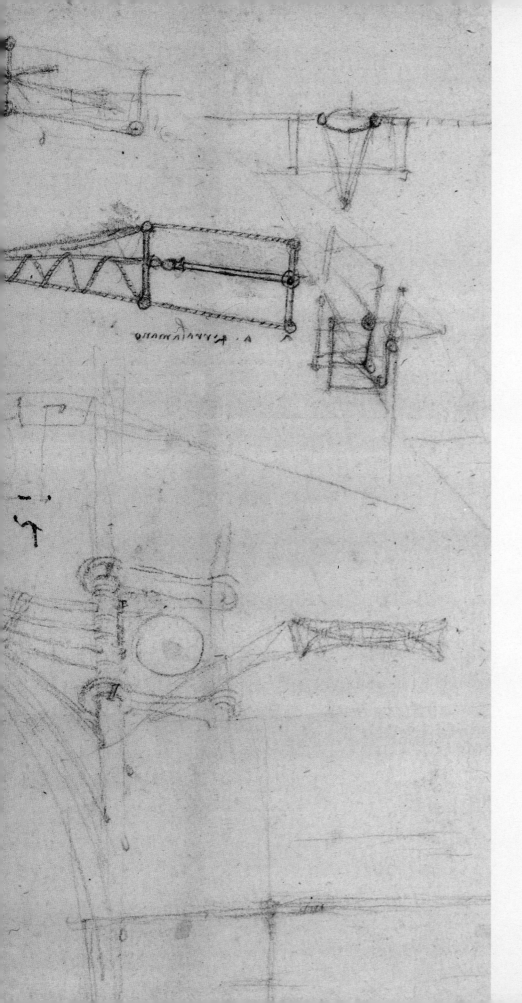

Force Diagrams

Milan
ca. 1483 - 1499

About a decade after arriving in Milan in 1483, Leonardo enters into an intense period of research on flying machines. During his work for Ludovico il Moro, he strengthens and develops his theoretical studies, especially in the fields of anatomy and mechanics. This research proves useful for his work on human flight, and he elaborates models of flying machines that use the dynamics of the human body to their fullest. Zoological observation, so fundamental to his early investigations, now becomes secondary with his design for the so-called 'flying ship', also known as the 'ornithopter'. In this phase of work there are other, very interesting developments, emerging from his studies on sailplaning.

Preceding pages: studies for the flying machine (ca. 1493-1495; CA 70br).

1-4 On a folio of the Codex Atlanticus (ca. 1493-1495; 1006v, full view and detail) Leonardo inserts a note and a drawing of the flying machine hanging from the ceiling of his Milanese workshop near the Duomo, the area shown in the fig. 4 photograph. This was the same place he was working on the colossal equestrian monument of Francesco Sforza (ca. 1490; W 12358r; fig. 3).

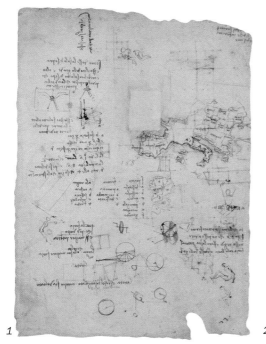

1

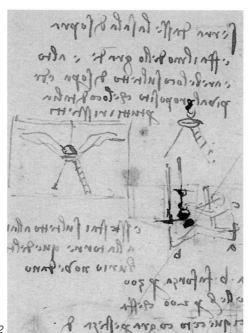

2

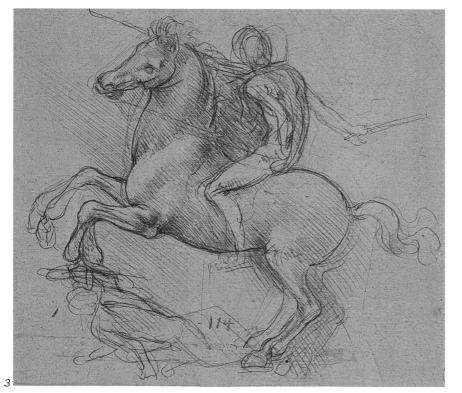

3

AN EXPERIMENT CARRIED OUT IN SECRET

'Board up the top room and make the model tall and large, and there is enough space on the roof, and it's higher than any other place in Italy. And if you stay on the roof alongside the tower, they can't see you from the tiburium' (CA 1006v).

This notation appears on a folio of the Codex Atlanticus next to two sketches for a flying machine (figs. 1 and 2) and, in a rather mysterious way alludes to an attempt to test the device. We are at the beginning of the 1490s, and Leonardo has been in Milan for about ten years. Ludovico il Moro has given him the use of some space in the Old Court, the residence of the dukes before their transfer, in 1467, to the Castello Sforzesco.

The Old Court was located next to the cathedral, on the site where the Palazzo Reale now stands (fig. 4), and during Ludovico's time was used to house important guests. It is here that Leonardo sets up his home and workshop. And it is here, at the same time he intends to test his flying machine that the work on the construction of the equestrian monument to Francesco Sforza is underway. A monument commissioned by Ludovico; a 'colossus' as the poets of the Sforza court described it. The horse was more than seven metres high (the equestrian statue of *Marcus Aurelius* on the Capitoline Hill in Rome, and the monument to Colleoni in Venice by Verrocchio are each about four metres high; fig. 3). Leonardo had prepared an 'earthen' model in clay and plaster that would then be cast in bronze (fig. 5). This project filled all of Milan with awe;

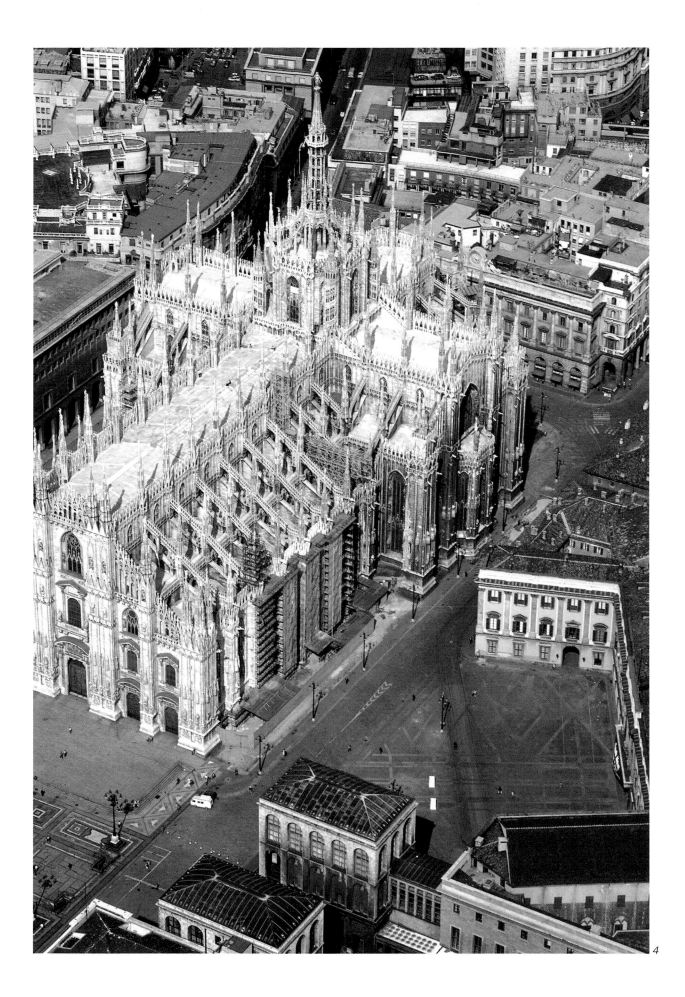

4

5 Study for the casting of the equestrian monument of Francesco Sforza (ca. 1490-1492; W 12349r).

6 Studies for the proportions of the human body in various positions (ca. 1488-1490; W 12132r).

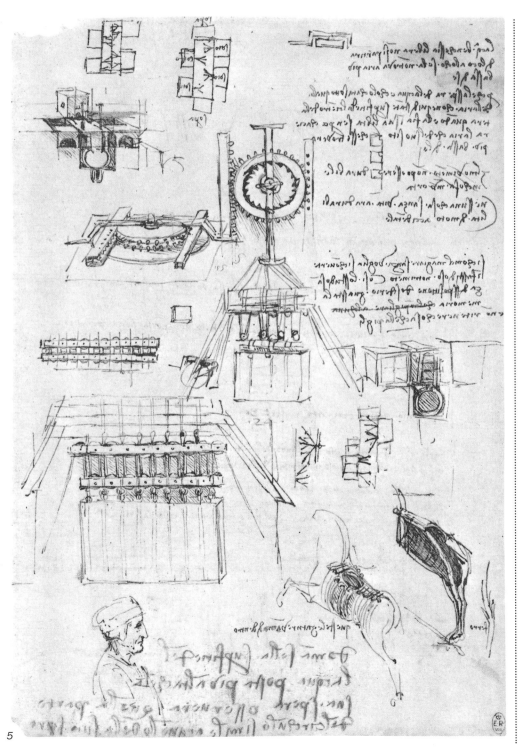

5

with as much awe as the *Last Supper*, the masterpiece that Leonardo was painting in the refectory of the convent of Santa Maria delle Grazie (figs. 42-44).

Even more awe and amazement – if that were possible – would have been aroused by a flying machine. Nevertheless, Leonardo intends to keep his project hidden from indiscreet eyes, at least for the time being. As surmised from the opening quotation, he therefore plans to board off one of his rooms in the palace, wherein the model for the flying machine will be built. The small sketch most likely depicts the machine during this phase, hung with a line from the ceiling of the room; the wings are visible, as well as a trestle-type landing device. The machine would subsequently be brought onto the roof, and, in order to prevent anyone working on the tiburium of the nearby cathedral from seeing the project, it should be placed on one side of the adjoining tower, hidden from view. This experiment was backed-up by intense theoretical work. Leonardo would continue his reflections on the animal world as an important aspect of his research, but between the 1480s and 1490s, his attention is drawn in the direction of the human body and its dynamic potentialities. This new horizon into 'anthropocentric' studies will be the runway for the development of Leonardo's ideas about human flight.

THE DYNAMIC POTENTIALITIES OF THE HUMAN BODY

When Leonardo arrives in Milan in about 1483, notwithstanding his admirable technical capabilities, boasted

7 Studies
 on the dynamic
 potentialities
 of the human body
 in various positions
 (A 30v).

8 Studies of the
 proportions
 of the human body
 in various positions
 (ca. 1488-1490;
 W 12136v, detail).

7

about in the presentation letter to il Moro, he still does not have a solid theoretical culture. He does not read Latin, the language of the majority of the texts dealing with official culture; and so he sets out to learn it. At the same time, he puts himself in contact with cultured individuals, hoping to obtain a book from which to study, or even better, have explained to him.

One of his first fields of study is mechanics. In a memorandum from that period, he writes: 'Have the friar at Brera show you *de ponderibus*' (ca. 1489; CA 611ar). We do not know who the Brera friar is; however, *'de ponderibus'* is the science of weights, that is, the mechanics dealing with the study of weight (statics), the causes or forces generated for movement (dynamics) and their intrinsic characteristics (kinematics). Anatomy is the other theoretical field that Leonardo begins to teach himself.

Leonardo's studies on human flight, carried out in Milan between the 1480s and 1490s, are fruit of these two fields of study: the anatomy of the human body and mechanics. He applies the study of statics and dynamics to the study of the human body and its movements.

About 1489-1490, Leonardo embarks on a systematic study of the measurements and proportions of the human body (figs. 6, 8, 9). One of the most unique aspects of these studies is that his measurements of the body are not made in only one, fixed and static position. The human body is also studied in all its possible variations when its

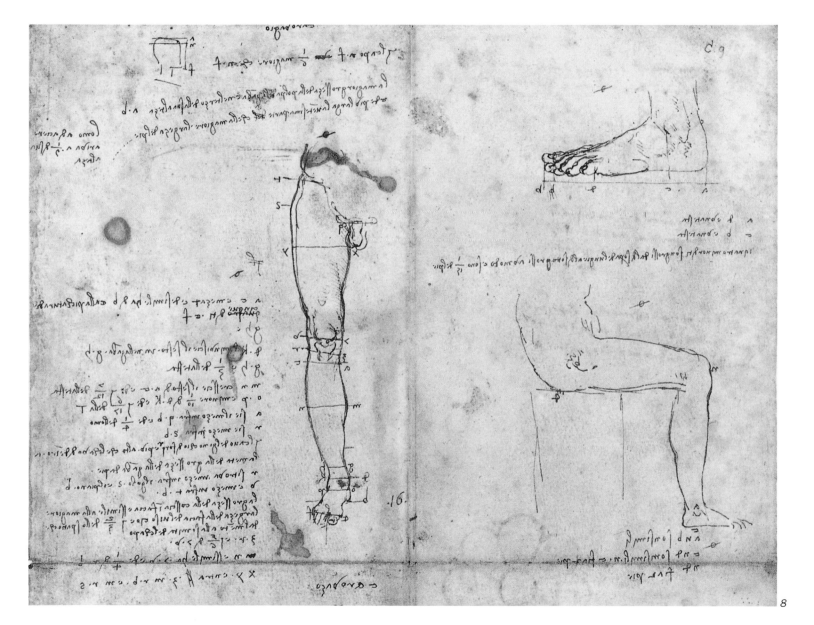

9 Measurements
of the proportions
and the dynamic
potentialities
of the human body
(ca. 1488-1490;
W 19136v).

10 Studies of the
proportions
and the dynamic
potentialities
of the human body
(B 3v).

11-12 Studies
on the dynamic
potentialities
of the human body
in function of flight
(ca. 1485;
CA 1058v).

13 Studies
on the dynamic
potentialities
of the human body
(B 90v, the study
in the middle
of the page).

9

10

11

12

position is changed. Measurements are made not just the in main standing position, but kneeling and sitting positions as well (W 19132r).

Using an analogous system of anatomy and applied mechanics, Leonardo also investigates the dynamics related to measurement and proportion (figs. 7, 9, 22). He studies how the human capacity to generate force varies with relation to body position.

At times, the two types of studies are contiguous with one another, even appearing on the same folio: for example, in W 19136-19139v (fig. 9) or, in B 3v (fig. 10).

In the series of studies made in Milan, considered to be Leonardo's earliest work on flight (CA 1058v; fig. 11), there is a prevalence of stylistically similar studies and drawings to this work on the dynamics of the human body. For example, Leonardo calculates the dynamic forces of a man by putting him on a large weight-bridge or mill-scale (drawing along the bottom left edge of the folio; figs. 11 and 12, detail).

Only in this case, the man is in a flying machine: he is on a scale, but moves a mechanical wing. On the same folio, Leonardo also asks himself if the weight of a man is greater when measured under normal conditions, pushing with his feet while standing erect, or pushing in a supine position. In fact, in one of the drawings (top left) he places two figures in the same machine, so that one can rest while the other is in motion.

Another example is found on folio 9v

14-16 Studies
on the dynamic
potentialities
of the human body
in various positions
on a folio containing
references

to the flying
machine
(ca. 1493-1495;
CA 1006v,
details).

17-18 Experiment
to test the capacity
of human force
to efficiently flap
the machine's

wing and the model
of the device
based on
Leonardo's
drawing.

14

15

16

of Manuscript B (fig. 13), where Leonardo attempts to show how the force corresponding to the weight of a human body – given as two hundred Florentine *libbre*, or about sixty-eight kilograms – can increase with different movements and positions of the body. By placing the shoulders against a beam and pushing against the scale with the feet, the weight-force can double reaching four hundred pounds.

Another very evident example of the close tie between his studies on the dynamics of the human body and flight is the Codex Atlanticus folio with the plan of an experiment meant to be conducted at the Old Court (ca. 1493-1495; 1006v; fig. 1).

In a series of small sketches appearing all over the folio, the dynamics of the body are studied in seven different positions (figs. 14-16). It is unclear whether all these studies make reference or not to a pilot in a machine. Nonetheless, the strong affinity, and even overlap, between the studies of the dynamic capacities of the human body and the designs for human flight is noteworthy. In fact, the crux of the problem is in simply generating the sufficient, required force.

During this period, Leonardo enriches not only his study of mechanics, but also ventures into the theoretical study of physics. One of the folios we have already looked at from the Codex Atlanticus (1058v; fig. 11) begins by posing the purely theoretical possibility of human flight based on dynamics and physics: 'The force that an object exerts upon the air is the same as the

17

18

19-20 The 'aerial screw' (B 83v) and the model based on Leonardo's drawing.

21 Studies on the dynamic capacity of the human body in rapport with various mechanical

devices destined for use in the flying machine (ca. 1487-1489; CA 873r).

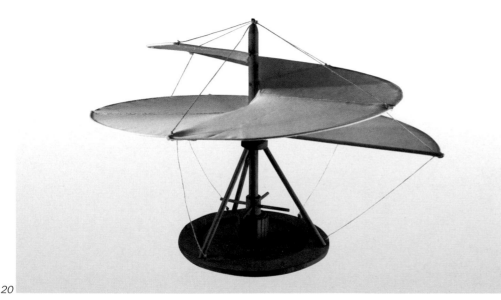

19

20

force exerted by the air on that object. When the air hits the wings, see how they keep the heavy eagle soaring in the thin, uppermost air, similar to the element of fire'. In fact, this is what Newtonian 'aerodynamic reciprocity' affirms: flight is a purely mechanical phenomenon, a result of the dynamic action between wing and air.

The wing strikes the air when it flaps (comprised of the downward and upward movements of the wing), and is itself struck by the air in the opposite direction. In the example Leonardo uses, when the eagle beats its wings in the air, the air exerts a force in the opposite direction keeping the bird in flight, just as the wind exerts pressure on the sails of a ship.

In the Codex Trivulzianus, a notebook containing some of Leonardo's most characteristic notes from his first period in Milan, he explains this theory more fully and introduces another important concept in physics: air can be compressed.

According to Leonardo air, unlike water, can be condensed if it is compressed fast enough so it does not escape into the air around it: 'Air can be born down upon, but water no, and when the thrust is faster than the escape, the part that is closer to the motor becomes denser, where it resists more' (CT 13v).

This theory sets off one of the most spectacular experiments during this period (B 88v; fig. 17). Leonardo proposes placing a membrane-covered wing on the edge of a hill, fixing to its base a thick plank weighing two hun-

dred Florentine *libbre* (ca. sixty-eight kilograms. This in turn is attached to a manually powered lever, lifting the plank when the wing is set in motion. What remains to be seen is if a man can activate the lever quickly enough to make it all work.

Similarly, even the so-called 'aerial screw' (B 83v; fig. 19) is based on the idea that air has material density that can be 'bored' into, and therefore a machine in the form of a screw with the right amount of speed ('quickly turned'), can move upward.

It is not clear how this screw action would come about: perhaps a line would have been wound around the central drum and then quickly unwound, like a spinning top; or perhaps two or more men would have pushed against poles fixed horizontally to the central axis.

Based on all these reflections, human flight simply becomes a problem of dynamics: how to flap the mechanical wings with enough force and velocity to compress the air and be lifted up. The pilot only generates the force, and the main question that concerns Leonardo is how to place and move the driver to obtain the maximum dynamic effect. And his studies on the dynamic potentialities of the human body demonstrate this concern.

AN IMAGE OF FORCE:
THE FLYING SHIP IN MANUSCRIPT B

Using an analogous thought process, Leonardo depicts the human body as a diagram of lines of force, and studies it through its interaction with mechan-

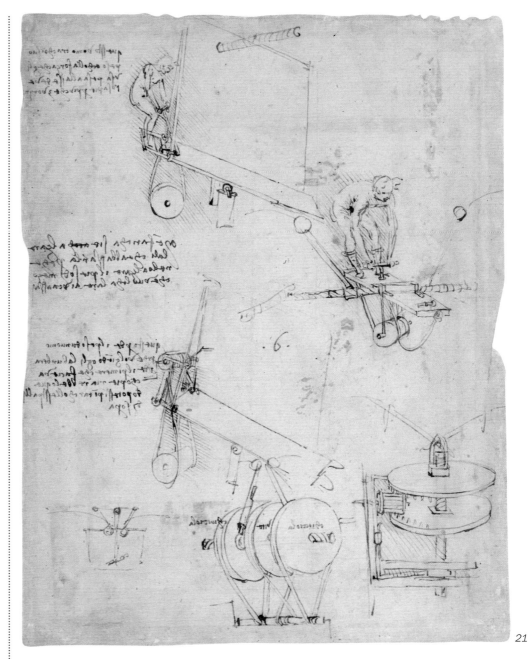

21

*22 Study of the
dynamic potentiality
of a sweep
in a chimney
(CF III 19v).*

*24 Study of the
dynamic potentiality
of the human body
in rapport with
a mechanical
device destined
for use in the
flying machine
(B 88r, detail).*

*23 and 25 The flying
ship (B 80r)
and model based
on Leonardo's
drawing.*

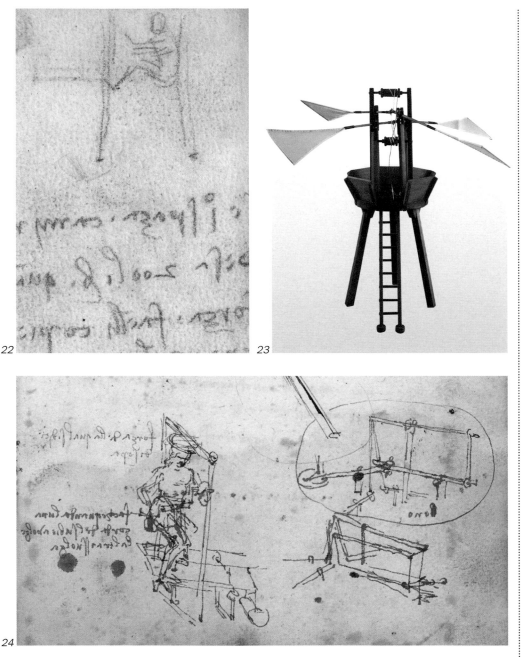

22

23

24

ical transmission devices (CA 873r and B 88r; figs. 21 and 24).

During this period he works on one of his most amazing projects (B 80r; fig. 25): a flying machine formed like the domed hull of a ship, with a pilot standing in the centre and four flapping wings.

More than just a project for human flight, it is a force diagram. It is Leonardo's response to the challenge of how to generate enough force from the human body to lift itself and the structure in which it is placed, into the air. Crouched down in the centre of the machine, the pilot generates force not only by pushing with his feet against the two pedals and turning the cranks with his hands, but also with his head, neck and shoulders.

The project is a framework for force lines very similar to Leonardo's sketches on the dynamics of the human body presented earlier.

The tight interior space is also very similar to another example found in these studies: the analysis of the dynamic potentialities of a sweep closed inside a chimney (ca. 1493-1496; CF III 19v; fig. 22). There is no note, no mention to be found in his plan for the flying craft of how the pilot will steer the machine in flight; he becomes almost an 'automatic pilot: he simply has to generate the force to lift off the ground.

Leonardo has also come up with a device that will transmit this force to the wings so they will flap. In essence, he uses a rope wound around two cylinders, one above the other, on

26-28 The central
shape dominating
the flying ship
(fig. 25)
also brings
to mind other
studies made
during the same
period: the plans

for a church
(B 18v, detail
and model based
on another drawing
by Leonardo)
and the study
of the skull,
with an attempt
to situate

the soul-common
sense in a central
point in the cranium,
similar to the pilot
in the centre
of the flying ship
(1489; W 19057r,
detail).

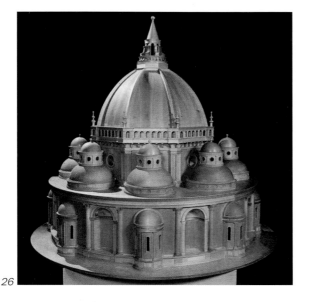

26

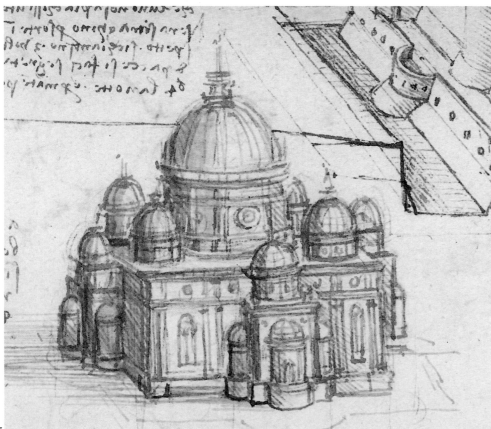

27

which the rope slides in an alternating up-down movement. There are two wings attached to each branch in the rope so that when one rope goes up, the wings attached to it go down, while the ones attached to the opposite branch, which drops, rise.

This mechanism occasionally appeared in previous studies, but now its dominates Leonardo's work. However, it is a very different machine from the one repeatedly found in earlier studies, and mentioned in our introductory chapter (cfr. figs. 11-14 and 34 in Chapter 1).

Instead of the pulley system, the wings in the previous design were connected and put in motion by a system of screws and lead screws. The pilot manoeuvred a handle bar and the alternating motion over the two screws moved the arms closer or farther, thus, lowering and raising the wings.

PROPORTION AND SYMMETRY:
THE IMPORTANCE OF THE CENTRE

One of the notations on the project for the flying craft reads 'This man, with his head, creates 200 *libbre* of force, and with his hands also 200 *libbre*; and he weighs the same. The movement of the wings will be alternating, like the gate of a horse, who is better at this than any other being'.

The forces generated by the pilot's body are equally distributed over three parts: head, hands and weight, represented in the feet.

Even the alternating movements of the two pairs of wings are distin-

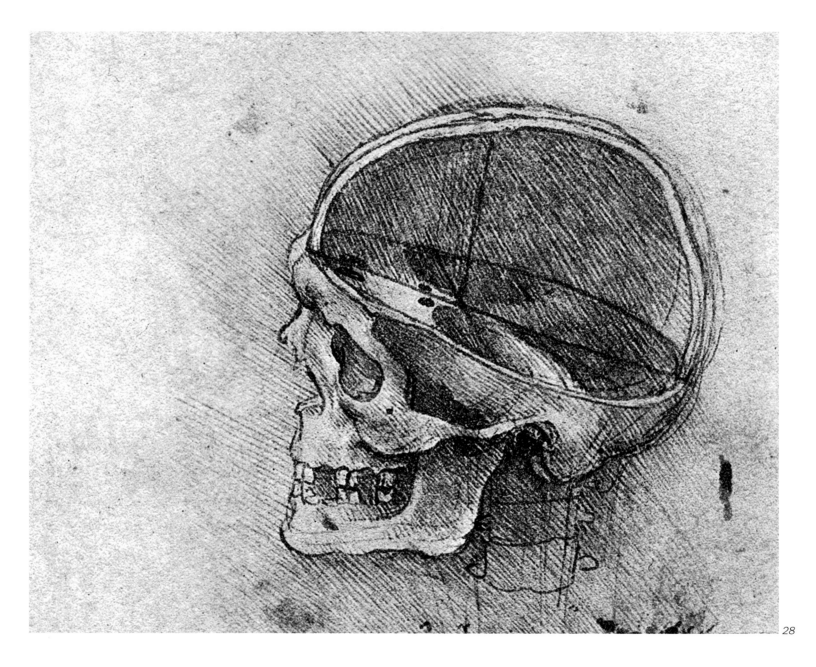

28

29-30 and 32 Flying machine with the pilot in a horizontal position (B 79r; CA 747r and B 75r).

31 Similar to the flying ship (fig. 25) and other studies (figs. 26-28), even the analysis of the dynamics of the human body is dominated by a centripetal

concentration (drawing from the late 1500s based on a lost study by Leonardo. Codex Huygens, New York, Morgan Library, f. 29, detail).

29

30

31

guished by their balanced harmony (two drop down as the other two go up, an alternating movement – Leonardo writes – similar to the legs of a horse in motion). The intrigue for Leonardo lies not only in the possibility that the contrivance can fly, but also its symmetry, the balanced proportion between its parts and its forces.

The wing crosspieces have arms measuring forty *braccia*, exactly twice the diameter of the flying craft from 'stem to stern', which therefore, must have measured twenty *braccia*.

The circular shape of the ship, the central position of the pilot, the equilateral crosspieces all introduce another theoretical field influencing human flight (at least in this case): the study of geometrical and mathematical proportions, and the search for the perfect proportions.

In the Renaissance tradition, and for Leonardo as well, perfect proportions are contained in those geometric figures having sides or parts equidistant from the centre: the circle, the square, the cross.

In Manuscript B, along with the sketches for the flying craft, an entire series of studies appears for buildings with a central floor plan based on the square, the circle and their various combinations (figs. 26-27).

A series of anatomical studies dating from the same time, depicts the sections of a skull. By using the measurements of bone morphology, a central, internal point can be calculated, which according to Leonardo is the meeting place of the senses, 'common

33 Membrane-covered
swimming glove
imitating a bat's
wing, similar to the
wing on the flying
machine
(B 81v, detail).

34 Working model
of the flying
machine
based on the
drawing (B 74v)
by Leonardo
(Florence, Istituto
e Museo di Storia
della Scienza).

35 Mechanical wing
(ca. 1493-1495;
CA 844r).

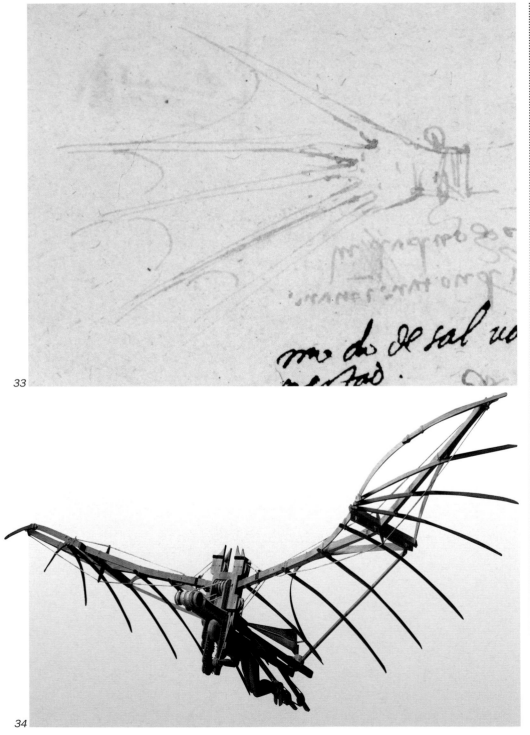

33

34

sense' and the seat of the soul (fig. 28). Finally, in this period, he carried out research known only to us through the copies in the so-called Codex Huygens (fig. 31). These are in-depth studies on movement of the human body, where the limbs are depicted as lines winding around central poles, in relation to a 'centre-soul', common to everyone and their origins, and clearly cited in a passage introducing the drawings: 'The force behind movement is in the bones and the nerves, however, motion comes from the spirit, the centre and soul of everything' (folio 11).

Leonardo's thoughts are now characterised by an even stronger tendency towards intellectualisation also involving his studies on flight (fig. 25). The flying machine becomes a structure with a 'central', symmetrical, well-proportioned form, with a pilot at the centre, representing for the machine what the 'common sense' is for the brain: the soul. A soul in this case that is the force and source behind movement.

REMNANTS FROM ZOOLOGY, ARTICULATED WINGS AND THE IMPORTANCE OF AGILITY IN FLIGHT

The dynamics of the human body, physics, proportions: during the 1480s and 1490s, these are the main theoretical areas on which the flying machine is based.

During the years in Florence, zoological research, an important means of theoretical emancipation from the practical mechanics of the workshop,

36 Flying machine
(ca. 1485-1487;
CA 824v).

37 Study of the whole
flying machine
(ca. 1493-1495;
CA 70br).

38 Study of the wing
structure on the
flying machine.

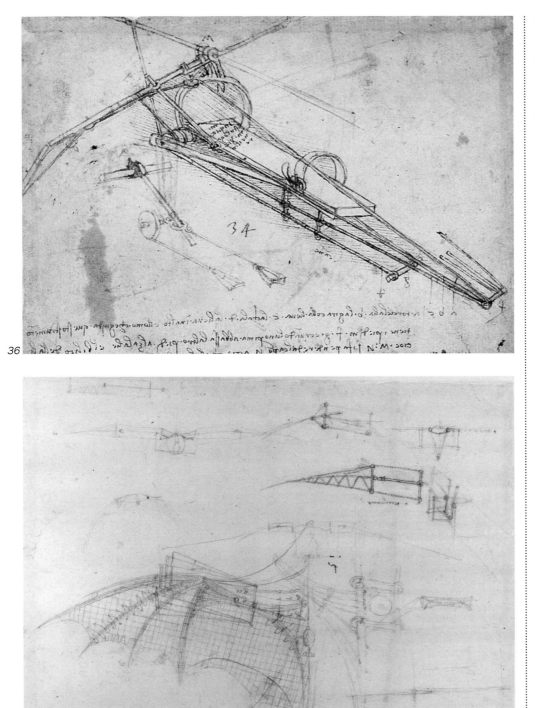

36

37

is for the most part now put aside. The definition of 'ornithopter', the term often used by da Vinci scholars in referring to the flying ship from Manuscript B (fig. 25), seems exaggerated: the alternating flapping of the wings and the retractable feet are the only zoomorphic elements in a machine that is largely the materialisation of theories of dynamics and proportions related to the human body. The zoological aspect emerges however in another series of study on flight, where the pilot is placed horizontally in the machine (B 79r, CA 747r, B 75r; figs. 29, 30, 32).

Here the increased interest in steering and changing direction of the machine in flight is the main difference in the studies on the flying ship. One of the projects (B 75r; fig. 32) even calls for a long tiller tied with a 'garland' around the pilot's head and neck, sketched in the upper portion of the folio next to the main drawing.

Even the pilot's movements are greater and more varied. Some of these are limited to making the wings flap, maintaining flight time and distance; other movements tilt the underside of the wings during the downstroke (so the air will be as 'compressed' as possible); still other movements angle the wing-edge into the air during the upstroke, more easily 'cutting' through the air.

In part, the wings are articulated so they can be folded or spread, movements that help maintain balance or change direction. In one of his first projects of this type (CA 747; fig. 30),

Leonardo adds sketches of jointed wings, with articulated segments capable of making the necessary flexion-extension movements, next to the full view of the design.

The pilot uses his hand or feet to make all these movements as well as maintain balance or to change direction. In some cases, certain movements such as the extension of the wings, are obtained automatically with springs. Increased attention to agility means closer imitation of the natural flight of birds, and consequently, an increased attention to the animal world.

Next to one of his more mature projects on articulated wings in the Codex Atlanticus, Leonardo jots down: 'out of sinew-wings or flying fish' (ca. 1493-1495; CA 844; fig. 35); that is, the wing should be covered with a membrane similar to a bat's wing or the fins on a flying fish.

Both these animals appear on a folio in the Codex Ashburnham I, dating from a few years earlier. Leonardo describes the flying fish as an 'animal who abandons one element for the other'. A few folios earlier, in Manuscript B (the Codex Ashburnham I was originally part of this manuscript) we find the study for a swimming 'glove' (B 81v; fig. 33), covered with a membrane as found in these animals.

The interest in the animal world leads man to compare himself with other species on earth, and just as in his period in Florence, Leonardo comes up with various ways for acquiring their same capabilities.

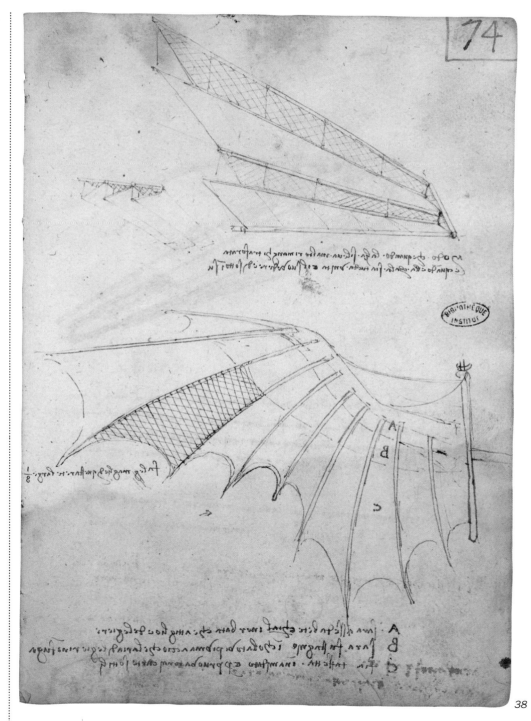

38

*39-41 Studies
 for the flying
 machine
 (ca. 1487-1490
 and 1493-1495;
 CA 848r, 846v)*

*and model in the
Museo Leonardiano
in Vinci, based on
Leonardo's drawing.*

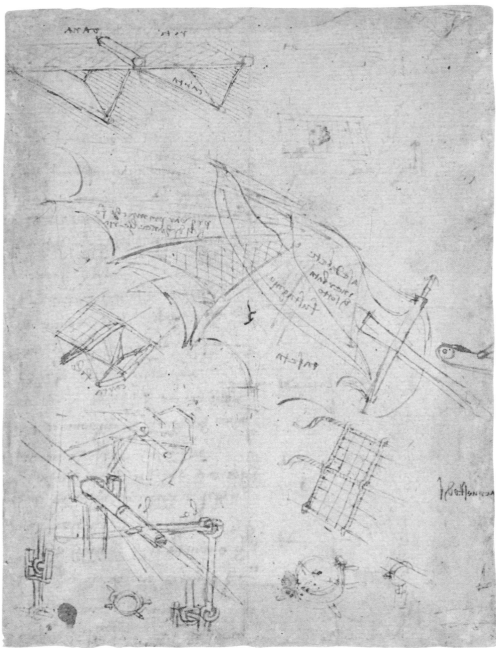

39

LACK OF A UNITARY PROJECT AND INITIAL SIGNS OF AN ALTERNATIVE: SAILPLANING

As seen from the studies examined to this point, a single, concise project design was not easy to develop. It seems that each problem posed by artificial flight based on the flight of birds is treated separately by Leonardo without coming to any final integration.

For example, he deals with the problem of force in the group of studies on dynamics and resulting in the flying ship. The problems of balance and agility are topics dealt with in the flying device with the pilot in a horizontal position.

Problems relating to the entirety of the wing structure, or proposing a completed machine, are not addressed by Leonardo in these studies. In some of the drawings (CA 747r and 824r; figs. 30 and 36) the flying machine is indeed fully sketched out, but these say little from a structural and design point of view.

At least one time however, the entire wing and the whole flying machine – wings and pilot – are dealt with in another group of studies (B 74r, CA 70br, 846v and 854r, centre detail; figs. 37, 38, 41 and fig. 28 in the next chapter). With the exception of the study in Manuscript B and another from the same period in the Codex Atlanticus (848r; fig. 39) all these studies can be dated to around 1493-1495, just prior to beginning work on the *Last Supper* (figs. 42-44). In 1496, Fra' Luca Pacioli arrives in Milan (fig. 46), and his

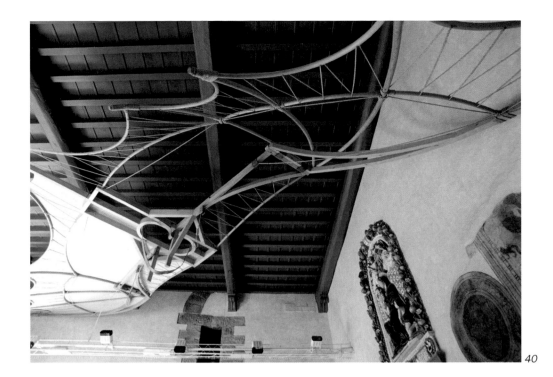

40

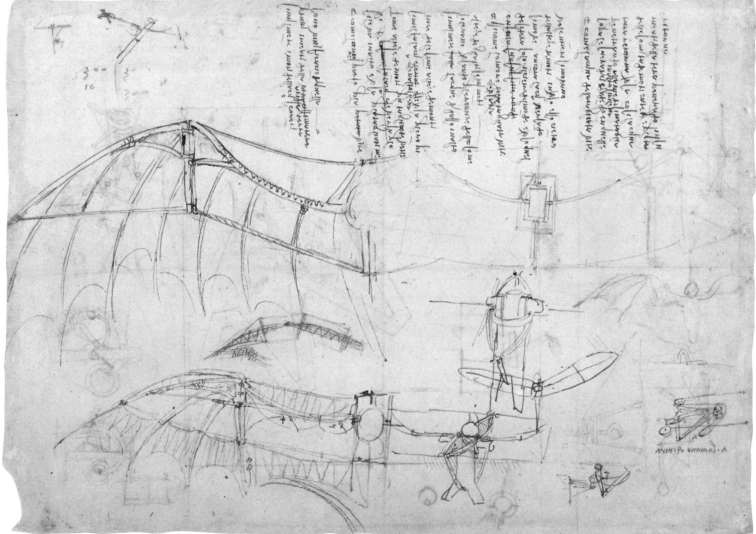

41

42-44 The Last Supper *(full view and details) painted by Leonardo during his years in Milan (ca. 1496-1498).*

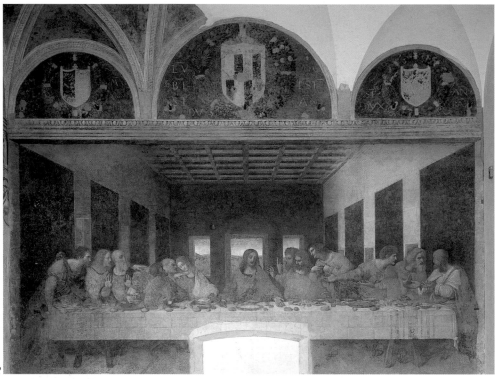

42

43

friendship with Leonardo helps to greatly improve the latter's knowledge of mathematics and geometry.

These are years of incredible intellectual synthesis for Leonardo; perhaps the most lucid time in his entire career. He plans and partially completes his writings on mechanics, optics, hydraulics, painting and anatomy. In the fields of art and science, the *Last Supper* (ca. 1496-1498) and the Madrid I Manuscript (the largest portion compiled in the 1490s) are, as a whole, the works where Leonardo most closely achieves synthesis in his research.

Finally, in the drawing in red pencil on folio 70br of the Codex Atlanticus (fig. 37) there is a detail of the pilot in his cockpit along with the two wings and their structures. In a certain sense, within the context of Leonardo's studies on flight, his study on wings and especially this preceding example, seems to represent a moment of finally attained synthesis with respect to the other two groups of study dating from a few years before.

But this synthesis is only apparent. The older studies attempted to imitate or recreate the natural mechanism of bird flight (in one case, the wingbeat for support, in the other, agility in flight). In this more recent and complete group of projects, however, the wing is limited to an articulated movement of the external part with respect to the rigid internal portion; a movement completely inadequate to sustain flight and only useful in completing some balancing manoeuvres.

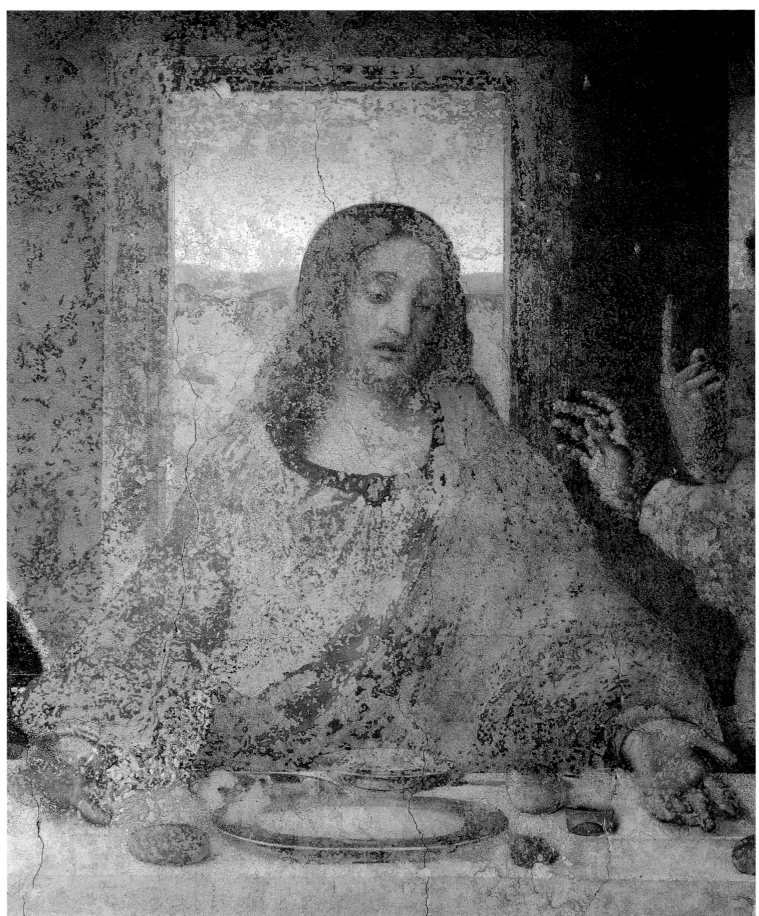

45 and 47 Study
for a parachute
(ca. 1485;
CA 1058v
and model based
on Leonardo's
drawing).

46 Jacopo de' Barbari
(attributed to),
Portrait of Luca
Pacioli, the great
mathematician and
friend of Leonardo;

they were both
in Milan during
the same period
(1495; Naples,
Capodimonte).

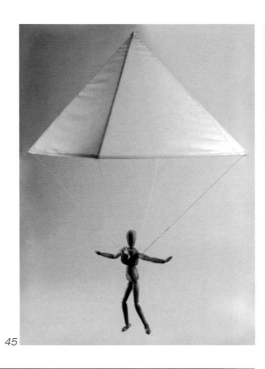

45

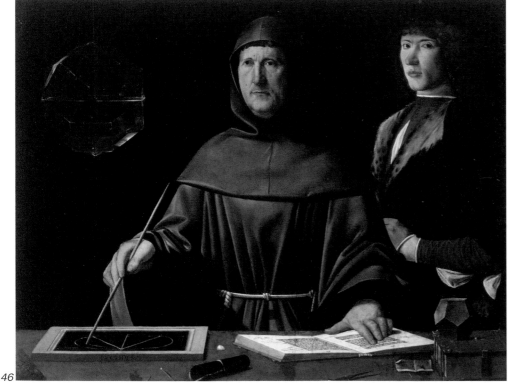

46

The analogy to nature seems to take Leonardo outside the animal world, towards another, more realistic and practicable alternative: sailplaning. In one of his drawings there is a winged seed (fig. 41) carried by the wind, and almost all these machines seem to be designed to sail through the wind, like a glider.

Years before, Leonardo had already begun the study of aerostatics, using a device that was part of the tradition of the *Quattrocento* 'inventors': the parachute. One of Leonardo's earliest reflections on flight as a mechanical phenomenon is found in the Codex Atlanticus folio 1058v. Here, there is the drawing of a parachute (fig. 47), and with this device a man 'can jump from any great height without injury to his body'.

As seen in the previous chapter (*ivi*; figs. 39 and 40), an anonymous Sienese engineer had already formulated this idea. Leonardo elaborates it on a less empirical basis. The principle of aerodynamic reciprocity, investigated by Leonardo while studying active flight produced by flapping wings, also allows for parachute flight. A man exerts pressure on the air slowing down the descent because of his weight and with a parachute of adequate height and breadth (both measurements being twelve *braccia*).

Analogous studies made a few years later using the winds for passive flight, are found on a folio of the Madrid I Manuscript (ca. 1493-1497; 64r; fig. 48). In the upper portion (fig. 49), a man is in the centre of a pierced sphere plac-

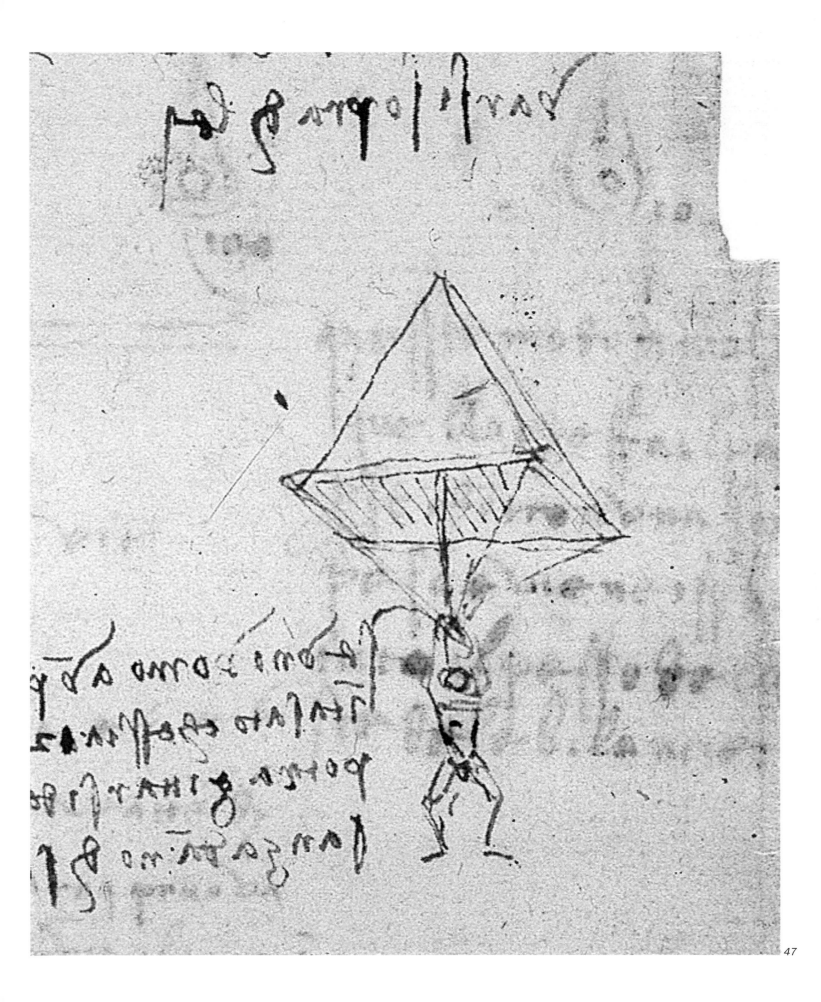

47

48 Model of a flying
 sphere (based on a
 drawing by Leonardo;
 Md I, f. 64r) reconstructed
 by the Museo Ideal
 Leonardo in Vinci.
 Man is always erect
 in a central position
 dominating
 the machine
 and the elements.

49 Model of a
 delta-plane wing
 (based on
 a drawing
 by Leonardo;
 Md I, f. 64r)
 reconstructed
 by the Museo
 Ideale Leonardo
 in Vinci and

the Municipality
of Sigillo,
and successfully
experimented
by Angelo D'Arrigo
(2003) in a wind
tunnel.

50 Two devices
 for flying using the
 wind, with a cockpit
 in the centre of a fan
 (top) or in the shape
 of an eagle directed
 towards earth with
 cables (bottom)
 (ca. 1495; Md I,
 f. 64r, full view
 and details).

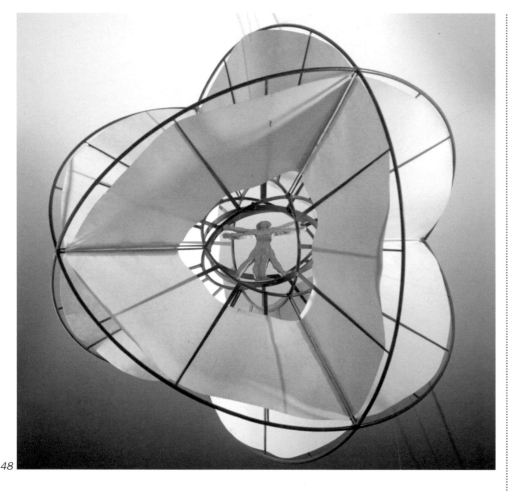

48

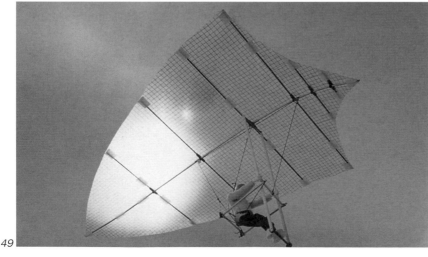

49

ed exactly in the centre of a fan sur-rounding it. Just as in a marine compass, this system is founded on the principle of a universal joint. Its motor is not dependent on manual force, but on the force of the wind. 'And put this device on top of a hill, in the wind, and it will go with the course of the winds, and the man will remain on his feet'.

In the lower portion of the same folio, there is an alternative project (fig. 50): the pilot is hanging from a kite, which is controlled from the ground, and by means of a cable can be steered even while in flight.

The same dichotomy appearing in flapping flight also appears in these studies: one project is dominated by a central form and only deals with the force necessary for flight; the other design, with its more longitudinal form, concentrates on both agility and balance, as in the machine with the horizontal pilot.

With these last two projects, we have now approached the same period as Leonardo's studies on the glider-type machine, mentioned previously, and based on very similar concepts. Leonardo's reflections on wind play a role in all these projects. Wind is a source of locomotion but it is also a disturbing, dangerous element.

During the course of the next few years, the problems relating to wind will attract Leonardo even more, becoming an integral part of his studies on a type of flight that is more imitative than natural, based on the movement of wings.

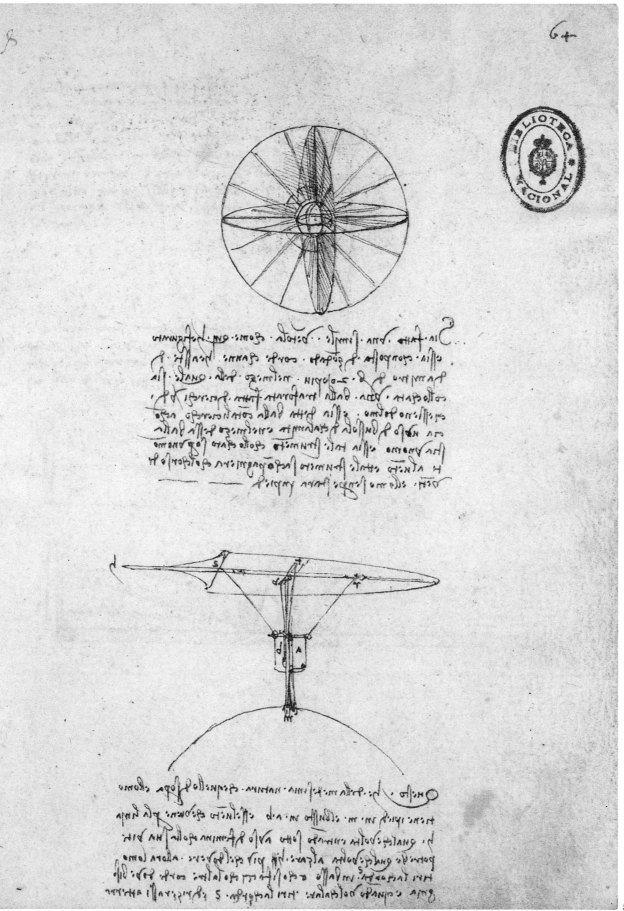

Following the invasion by the French, Leonardo leaves the Duchy of Milan, and in 1500 returns to Florence where he continues work on the flying machine. Studies of the animal world dominate this period, and his observations on the flight of birds take the foreground. His anatomical studies of the human body and its dynamic potentialities, nucleus of his work in the previous phase, are put aside for now. At the same time as his renewed interest in the animal world, Leonardo enters into a phase of technical design based on the principle of imitation, and his studies into human flight are increasingly directed towards reproducing natural flight. Thus, technical imitation is a means for artificially re-creating nature, and just as in painting, Leonardo views it as a copy of nature. Indicative of the continuity between human flight and natural flight, Leonardo now calls his flying machine 'bird'.

Preceding pages: study for a mechanical wing (CV 7r).

1-2 At the beginning of the 1500s Leonardo often goes to the hills around Florence, near Fiesole, to study the flight acrobatics of birds.

3-4 Codex K and Codex L are two small pocket codices where Leonardo could jot down notes during his excursions into nature.

1

NATURE IN THE FOREGROUND: THE OBSERVATION OF BIRDS IN FLIGHT

'Like the *cortone*, the bird of prey I saw on my way to Fiesole, above the locality Barbiga, in 1505 on the 14th of March', this is Leonardo's notation on folio 17r of his Codex 'On the Flight of Birds'.

When he makes this notebook entry in 1505, he has been back in Florence for five years. It is here where he dedicates much of his time to observing birds in flight and one of his favourite places to fill up his notebook is the hills surrounding the city, near Fiesole (figs. 1 and 2).

One day, while walking through the hills in the area known as Barbiga, he notices the unique way the *cortone*, a bird of prey (*l'uccello di rapina*) with a characteristically short tail, soars in flight. In another note in the Codex 'On the Flight of Birds' we learn that Leonardo decides to test his flying machine in the area around Fiesole.

He chooses Monte Ceceri, named after the large, soaring birds always in the vicinity: the so-called *ceceri* swans, a bird with a wart-like growth shaped like a *cece*, a chickpea, on its beak. 'The large bird's first flight will be on the back of the great Cècero', he writes, 'filling the universe with awe, filling all the writings with its fame and with eternal glory the nest from whence it was born' (CV; inside front cover).

During Leonardo's previous period in Milan his studies on the animal

world had, at least partially, taken a supporting role. Now, after 1500, they regain centre stage. As we have seen, the projects undertaken by Leonardo towards the end of his stay in Milan, are more complete, synthetic, using the winds for soaring flight.

Nevertheless, they are not the first indications of new horizons in his research. On the contrary, the studies undertaken after his return to Florence, indicate just the opposite.

Leonardo now turns his efforts to designing a flying machine not only capable of movements requiring balance and agility, but also having the force required for flapping flight. In both these areas however, Leonardo now gives increased attention to the animal world.

Thus, the observation of the behaviour birds in flight acquires unprecedented intensity in Leonardo's studies. As a result observations made in three of his manuscripts date from about this period: Manuscript L (ca. 1497-1504; fig. 4), Manuscript K^1 (ca. 1503-1505; fig. 3) and the Codex 'On the Flight of Birds' (ca. 1505).

MANUSCRIPT K[1]

The first two manuscripts are basically pocket notepads, measuring about 9 or 10 cm x 7 cm. It is therefore feasible that at least some of his notes and sketches were made 'en plein air', notes jotted down in hurried handwriting as found in Manuscript K^1 (one of the pocket notepads part of Manuscript K; figs 5-8). Confirming this hypothesis, all the notes

2

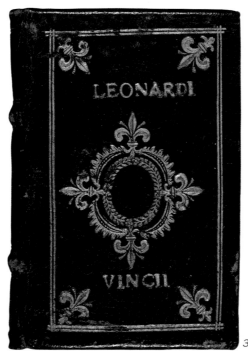

3

4

5-8 Codex K¹
(9r, 7r, detail
of 10r, 6r).
The notes
penned-out
in this codex
on the flight

5-8 Codex K¹ (9r, 7r, detail of 10r, 6r). The notes penned-out in this codex on the flight of birds were probably copied into a more complete collection of studies.

in this small codex were crossed out or have a cross-mark next to them, as if they were jotted down and later copied or developed into expanded notes and observations that are now lost. Certainly the quotation at the opening of this chapter on a hawk taking off into flight, must have been made and recorded outdoors near Fiesole. Leonardo jotted it down in the Codex 'On the Flight of Birds', a slightly larger notebook (21 x 15 cm) with respect to the other two.

In fact, all the observations in Manuscript K¹ deal exclusively with the flight of birds, analysed from two different aspects. The first aspect deals with turning manoeuvres or equilibrium maintained in the wind. The other addresses the behaviour and mechanisms of active flight, 'without the favour of the wind' and obtained by flapping the wings.

Between the 1480s and 1490s these two types of flight characterised his projects for mechanical flight. Leonardo studies them now in relation to natural flight.

Even though the notes in K¹ are all directed toward this naturalistic study, they end with a very clear plan that brings the flying machine, instrumental flight, back into play: 'Divide the treatise on birds into four books, the first on flight maintained by beating the wings; the second on flight without beating wings, maintained by the wind; the third about flight common to birds, bats, fish, animals, insects; the last about instrumental motion' (K¹ 3r).

9-11 CV 17v and 18r;
and, below, 16v-17r.
On folio 18r
Leonardo studies
the flapping
of a bird's wing,
which he then tries

to imitate in two
alternative projects
for the wing of
the machine
on folios 16v-17r.
This proves
he continues

to believe
in the possibility
of active human
flight attained
by flapping the
machine's wings.

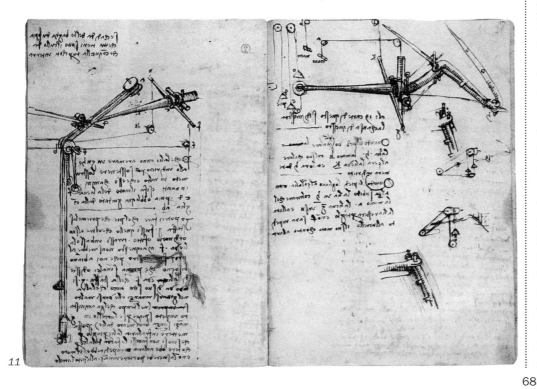

9

10

11

Similar to the Codex 'On the Flight of Birds', the small K[1] codex, was written beginning with – what would be for us – the last page. Therefore the passage just quoted from folio 3r is at the end of the notes on natural flight, which begins on folio 14r.

As Leonardo affirms, the treatise would consist in a large section dedicated to natural flight, examined in its two aspects: 'by beating of wings' and 'without beating of wings, by favour of the wind'. The naturalistic and theoretical sections would be integrated by a practical and a technical part on the flying machine ('instrumental motion').

This double program, the study of both aspects of bird flight and its application to mechanical flight, is in part completed in the Codex 'On the Flight of Birds', and seems to postdate the small K[1] manuscript.

THE CODEX 'ON THE FLIGHT OF BIRDS'

Even though Leonardo's written works lack sequential order, in the Codex 'On the Flight of Birds' two distinct sections can be identified.

The first part is made up of pages with higher numbers because of the reverse order of compilation, and, for the most part deals with flapping flight. The second part, the folios with lower page numbers, is mainly concerned with equilibrium manoeuvres in the wind. Both these sections contain notes on the flight of birds followed immediately by drawings attempting to reproduce these

FREUD AND LEONARDO'S CHILDHOOD MEMORY

Between the late Nineteenth and early Twentieth centuries, there is a growing interest in Leonardo's work. The Codex 'On the Flight of Birds', printed in 1893, is only one example.

A famous biography on Leonardo, written by Merezhkoskij, came out at the beginning of the 1900s. All this must have helped attract the attention of Sigmund Freud, the father of psychoanalysis.

In 1910, Freud published a small work, important not only in the history of psychoanalysis, but in Vincian studies as well: *Leonardo da Vinci and a Memory of His Childhood*.

As the title clearly indicates, the study centres around a memory Leonardo writes down in the margin of his studies on flight. While he is intent upon observing birds in flight in order to understand their secrets, his mind is stimulated by the memory of a re-occurring childhood dream. In his cradle he is attacked by a bird, a black kite that beats his tail on the inside of the young child's mouth (the passage is on page 89).

Freud wants to reconstruct Leonardo's psyche, his impulses, his emotional world. The centre of Freud's analysis is not Leonardo's art, but his per-son. The main difficulty is in working with a figure from the past; Freud could not use the usual psychoanalytical technique of a person reclining on the analyst's sofa.

His work was experimental: it was an attempt to psychoanalyse a man who had lived four centuries earlier, departing from what he had left: his works, made up of all types of writings and art.

Among Leonardo's writings, childhood memories could not pass unobserved because they play a fundamental role in psychoanalytical practice. In Freud's hands Leonardo's memories provide a key to understanding some of the aspects of Leonardo's character, such as the unfinished aspect of his artistic and scientific works, his perennial dissatisfaction and reluctance to give closure to a piece of work.

Based on Leonardo's memory, Freud deduces the artist's homosexuality, and continuing his analysis, attributes its origin to the fact that Leonardo spent the first years of his life in the company of only his natural mother before being accepted by his father and his stepmother.

Freud sees the ambiguous presence of the natural mother and the stepmother in many of Leonardo's paintings, for example, *The Virgin and Child with Saint Anne* in the Louvre. He also cites an interpretation where the Virgin's mantle forms the shape of a vulture, pointing its tail towards the Child's face.

The Virgin and Child with Saint Anne *(Paris, Louvre) work in which Freud (in photo to the left) sees the emergence of the memory of Leonardo's difficult relationship with his natural mother and his stepmother (the shape of a vulture is said to be hidden in the Virgin's mantle).*

Below, the passage with the childhood memory upon which Freud based his analysis (ca. 1503-1505; CA 186v).

12-14 CA 843r
(1503-1505,
detail),
CV 16r (detail),
CA 825r
(ca. 1503-1505);
study for a system

to rescue the pilot
using inflated
wineskins wrapped
around his body.
In this folio
Leonardo
undertakes

the comparison
of the dynamic
capacities between
birds and man,
which he develops
in CA 843r
(fig. 12)

and 825r
(fig. 14),
using the
'anigrotto'
(perhaps a crane
or pelican).

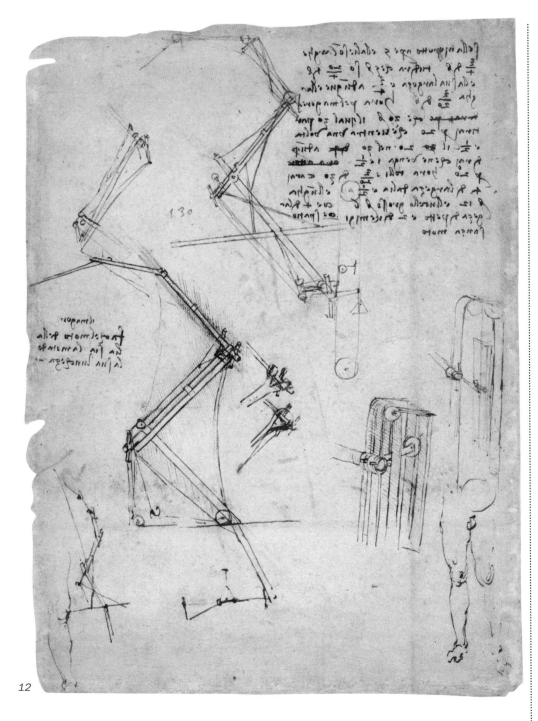

12

natural movements using a flying machine. Even more so than during the period in Milan, Leonardo's concept of human flight strongly imitates nature. He observes nature in order to re-create it, just as he does for painting.

Simply being able to fly is not enough; the goal is to re-create, in form and function, a machine with the same characteristics as creatures who fly naturally, like the birds. At least from this point of view, today's modern, engine-driven flight would have certainly disillusioned Leonardo.

The rigid wings and body of the aeroplane, the presence of an engine that has nothing to do with the wings in terms of dynamics, are exactly the opposite of bird flight.

It should be emphasised, however, just as he had done before, Leonardo continues to deal with the problem of 'force' (flapping flight) and 'agility' in flight (sailplaning) as two separate problems, without proposing a model for a machine that synthesises the two functions.

THE FIRST PART OF THE CODEX 'ON THE FLIGHT OF BIRDS': FLAPPING FLIGHT

Leonardo's reflections on flapping flight are concentrated in the first (chronologically, the last) folios in the Codex (figs. 9-11), that is, from 18r to 16v.

As a first step, Leonardo studies the flapping movement in birds necessary to fly in the absence of wind

(18r, the two drawings on the upper right and the adjacent notes; fig. 10).

In the first phase, the end of the wing, or hand, functions just like a swimmer's hand in water: the back portion lowers and tilts the face of the wing towards the air, gaining lift and forward propulsion.

During this phase, the elbow, or internal part of the wing is raised and angled into the air to reduce resistance and help forward progression.

After the propulsion beat, the hand of the wing quickly turns upward before beginning a new beat. In theory, during this interval, the bird should drop. Instead, it remains suspended in the air, moving forward thanks to the wing section nearest the body (elbow or arm) that lowers and opens the inner face of the wing into the air, with a slight backward twist.

Thus, the air is condensed in the form of a cone-shaped cushion (the so-called 'wedge effect') on which the bird continues to be suspended and slides forward due to the thrust created during the previous beat from the hand of the wing.

In the following folios, 17r and 16v (fig. 11), the designs for the flying machine are the direct attempt to mechanically reproduce this natural wing movement.

In one of these two projects (17r) Leonardo draws the left wing of the machine, seen from the front.

This wing is connected to a moveable pulley, and using two pedals attached to cables on the pulley, the pilot can raise or lower the wing with

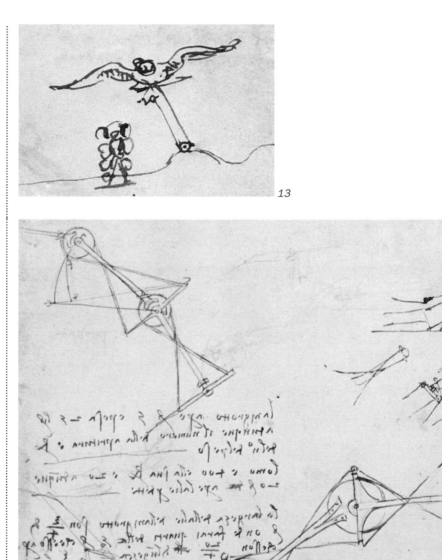

13

14

15 CA 1030r
 (ca. 1505):
 Studies for the
 mechanical wing
 and comparison
 of the dynamic
 capacities between
 man and the
 swallow.

16 CV 9r: this is
 the first folio
 in a section
 of the codex
 dedicated to
 the equilibrium
 manoeuvres used
 by birds for soaring
 in the wind.

15

his feet. At the same time, the pilot's hands work two cables connected by two wheels to a handlebar overhead that is joined perpendicularly to the wing.

The wing is thus rotated and is open to the air in the downstroke, while in the upstroke, it is angled into the air. Just like the flapping flight of birds in the absence of wind.

In all the drawings on this folio, the machine's wings are situated laterally, at the same height as the pilot. The solution presented in folio 16v is different. Here, there are two pulleys: the upper one attached to the wings, and the lower one with pedals worked by the pilot.

A wheel between the two pulleys transmits the movement generated by the pilot on the lower pulley to the wings, attached to the upper pulley. The manual twist in the wing is produced with two systems of rings-cables-wheels placed under the wing and the corresponding handlebar.

As in the adjacent folio, this twisting movement is used to angle or open the wing, necessary for flapping flight, and therefore obtained by exerting force, and not from the wind.

As seen from these studies, in about 1505, Leonardo designs still another machine meant to lift off from the ground and fly, using forces generated by man, just as in the studies dating from the 1480s on the flying ship.

However, there is one important difference. Now, the point of depar-

17-18 CV 8v and 7v:
Studies on the
equilibrium
manoeuvres
of birds
in gusting wind.

ture is no longer the human body with its static and dynamic potentialities, but the body of an animal.

The structure of the animal must be compared with the human body; the mechanical wings must conform to the wings of birds.

On folio 16r (fig. 13), Leonardo writes that human flight may seem impossible, because based on anatomical differences, birds seem to be able to flap their wings with a force that man does not have.

In fact, unlike man, birds have powerful pectoral muscles to move the wings; they have a single, solid sternum and the wings are interlaced with muscles and very strong ligaments.

Leonardo's response is that birds normally use only a small part of their dynamic power for flight and balance. Only on certain occasions do birds require great force in flight: fleeing from predators, or, pursuing and capturing prey.

Thus, the force necessary for flapping flight is also attainable by man. In this new phase of reflections on flight, man is no longer at the centre of the research; birds and their body structure are where Leonardo begins. Some of the Codex Atlanticus folios (843r, 825r and 1030r; figs. 12, 14, 15) dating from this period, indicate this direction in Leonardo's studies.

The wing dimensions capable of maintaining man in flight are calculated by studying birds such as the crane or pelican.

17

19-20 CV 7r and
(next page) 6v;
studies for the
mechanical wing
meant to imitate
in-flight equilibrium
manoeuvres
of the birds
studied in the
preceding pages
(cfr. figs. 17, 18, 23).

19

THE SECOND PART OF THE CODEX 'ON THE FLIGHT OF BIRDS': EQUILIBRIUM IN SOARING

As the compilation of the codex progresses, especially from folio 9r (fig. 16) on (for us, going towards the beginning), Leonardo concentrates more and more on another problem pertinent to both birds and flying machines: maintaining flight equilibrium in the wind.

In this case the wind supplies the thrust and the pilot and the machine have only to remain balanced, turn, remain agile in a sudden gust of wind. Folio 9r (fig. 16) is entirely dedicated to the manner in which a bird attains horizontal equilibrium after being pushed vertically by a lateral gust of wind. To accomplish this, birds spread or fold their wings on one side, using the wind as a counterweight to regain equilibrium, just like a set of scales.

Leonardo expands on his analysis in the subsequent folios (8v, 8r, 7v; figs. 17, 18, 23), showing how the tail and the *alula* (or bastard wing: a tuft of small, stiff feathers on the first digit of a bird's wing) help in maintaining equilibrium and in executing turns. Therefore, at the end of this copious series of notes on flight equilibrium of birds in the wind, Leonardo perfects some of his mechanical designs (7r and 6v; figs. 19-20) attempting to imitate these natural movements. No longer is the wingbeat the nucleus of these projects, it is replaced by studies on wing flexion-extension.

21

Even though spreading and folding movements contribute to propulsion, these studies are principally aimed at balancing manoeuvres when faced with the danger of 'capsizing' (6v) in the machine due to 'the fury of the air' (7r).

The pilot flexes and extends the articulated wing using tie-rods, changing the wings' exposure to the wind based on the direction in which the wind is gusting.

A fundamental premise to these manoeuvres is that the machine must fly high enough in the air in order to have the room and time to regain equilibrium before crashing to the ground: 'This bird, with the help of the winds, must reach a great height, and this is its security' (7r).

THE THIRD PART OF THE CODEX 'ON THE FLIGHT OF BIRDS': PRINCIPLES OF STATICS

Leonardo makes no attempt to integrate the projects for soaring flight with those based on the flapping flight, developed at the beginning of the codex.

However, another section of the Codex (folios from 4v to 1r; figs. 21, 22), is dedicated to statics, and is an appendix to his studies of flight contained in the preceding folios. In addition to observation of natural flight, this section primarily deals with theoretical considerations on statics.

Many of the principles of statics, which in this section are considered from a purely theoretical point of

view, were applied in the understanding of natural flight and the plans for artificial flight in the preceding pages. Here, for example, Leonardo reasons on topics such as the centre of gravity, or, the analysis of the static behaviour of a body using the so-called inclined planes.

It should be emphasised that during this period, Leonardo's knowledge of statics and dynamics no longer generates an *a priori* design for the flying machine, as if it were the visualisation of a dynamic theorem. He has reached a greater balance between mechanical theory, the study of natural flight and mechanised design.

The form and function of the latter, are dependent for the most part on his natural flight studies even if they are spanned by subtle considerations on statics and dynamics.

KNOWING AND DOING COINCIDE: THE FLYING MACHINE COPIES NATURE

Like painting, the project for the flying machine is the mimesis or imitation of nature in Leonardo's technical studies. Leonardo relentlessly attempts to re-create the flying creature that nature has already mastered. His is a fundamental mimesis that goes beyond painting.

This time Leonardo intends to re-create what is spatially real in nature, emulating the natural model, imitating both the form and the functional capability of bird flight. After 1500, when Leonardo again

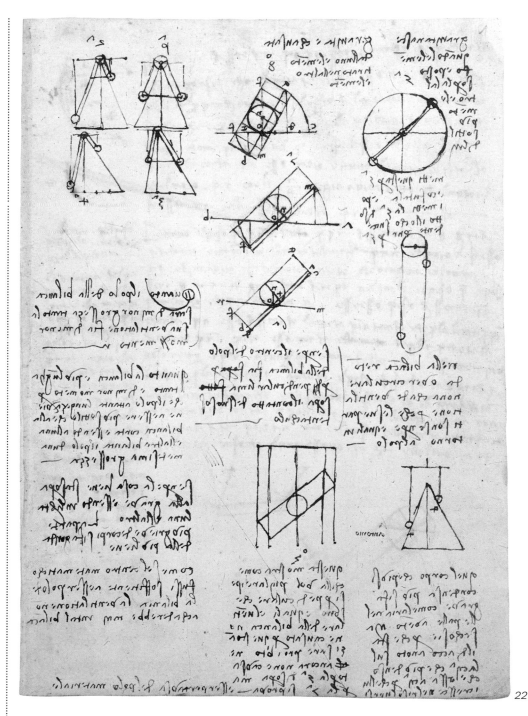

22

79

23-24 Studies
 on the equilibrium
 manoeuvres
 of birds (CV 8r;
 full view and detail).
 In the drawing
 reproduced in the
 detail (fig. 24)
 and in the notes,

Leonardo goes
 from thoughts
 on the bird
 in nature to those
 on the machine
 with a pilot.

23

takes up his studies on flight, as witnessed by the Codex discussed in this section (today, in the Biblioteca Reale in Turin), the term he most frequently uses when referring to the flying machine is 'bird'. As never before, knowing and doing coincide perfectly, and the continual osmosis between observation of nature and technical reproduction become truly superimposed.

In Leonardo's mind, observation and the study of birds at times coincides with the artificial re-creation of the animal in nature; and, almost without our realising, Leonardo crosses between one and the other.

For example, in the second part of the Turin codex, all his notes on the studies on equilibrium manoeuvres of birds (9r, 8v, 7v) are written in the third person and refer to the machine, for example: 'When the bird is upwind turning its beak' (8v).

Right in the midst of these observations (8r; fig. 23, with similar drawings of banking birds), the notes change to the second person, almost as if Leonardo was addressing himself or the pilot of the machine: 'If the wing and the tail are too far upwind, lower half the wing'.

Leonardo seems to refer to these 'suggestions' or rules in folio 6v (fig. 20), containing notes and designs for the machine: 'And in addition to this, if the bird turns upside down, you have plenty of time to right it before it hits the ground, following the orders already given'.

In one of the drawings on folio 8r

(fourth from the top; fig. 24), the outline of the bird seems almost to take on a human form, an ornithopter. This conceptual and visual 'metamorphous' is even more evident on folio 15r (fig. 25).

The two upper drawings and the one on the bottom clearly refer to a type of bird. The two centre drawings with notes on flight equilibrium seem, however, to depict a flying machine.

The circle drawn under the wings, containing a smaller, internal circle could schematically allude to either the body and head of a bird, or a pilot in his cockpit, as seen in an analogous drawing on folio 12v (fig. 26), with notes on the flying machine. Another drawing in the upper part of the same folio 12v schematically shows a pilot with wings at his side. Here Leonardo has drawn lines on the probable rupture points for the machine under excessive stress.

The similarities between birds in flight and copying them, is applied to the structure of the flying machine, and in particular, the wings.

In the same manner Leonardo calls his machine, 'bird', its parts are also indicated by anatomical terms: the tie-rods to move the wings are called 'nerves' (for example, folio 6v), and the wing tip is referred to as 'fingers' (for example, folio 7r).

Even the study on the anatomical structure of a bird's wing during flight demonstrates Leonardo's increased attention to nature, characteristic of his studies on human flight

24

25-27 CV 15r and 12v (with detail of the latter).

28 The study on the bottom (CA 854r) is almost certainly for the wing of a machine, however, it is so similar to a natural *wing with its bone segments and joints that it leaves some doubts (the fragment in the centre of the page refers* *to a flying machine and dates from an earlier period; ca. 1487-1490).*

25

26

27

from this period. The wing anatomy in nature and the 'anatomy' designed for the machine also overlap.

For example, in the Codex Atlanticus (854; fig. 28), the wing drawn is almost certainly a mechanical wing. However, there are close similarities to a natural wing, dissected and drawn in order to study the structure. As demonstrated by two drawings in the Codex 'On the Flight of Birds' (11v; fig. 29), Leonardo's mechanical wing in terms of articulated bone structure is very close to the version found in nature.

Designs for an articulated wing become increasingly similar to natural wings over time. The most mature example of this similarity, other than those already mentioned, is found in the project on folio 934, Codex Atlanticus (ca. 1505-1506; fig. 31).

Recalling the numerous and complex systems of stirrups and propellers in Leonardo's drawings from the 1480s and 1490s, we realise that in these later designs the pilot moves the wings using less 'machinery', using fewer and more direct systems of rods and pulleys.

Even the internal structure of the mechanical wings looks like the wing structure of birds. Leonardo is still confident that he can emulate both flapping and soaring natural flight, but his approach is subtler, closer to nature.

His thought process also moves in a more naturalistic direction. Almost contemporary to the Codex 'On the Flight of Birds', is his lost pictorial

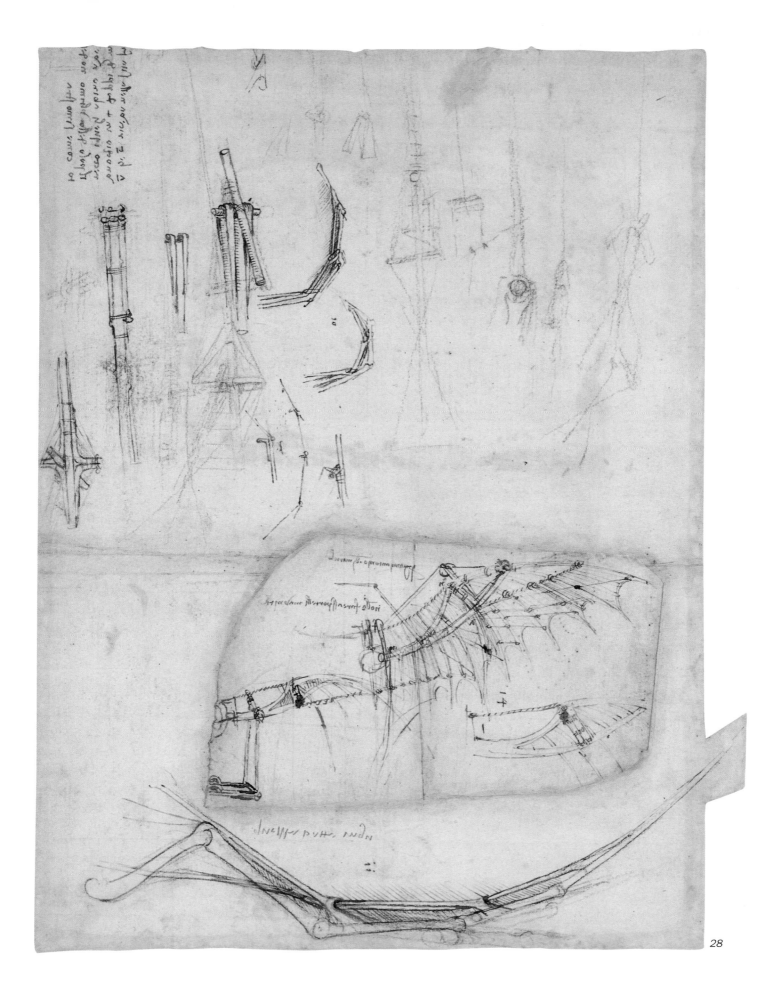

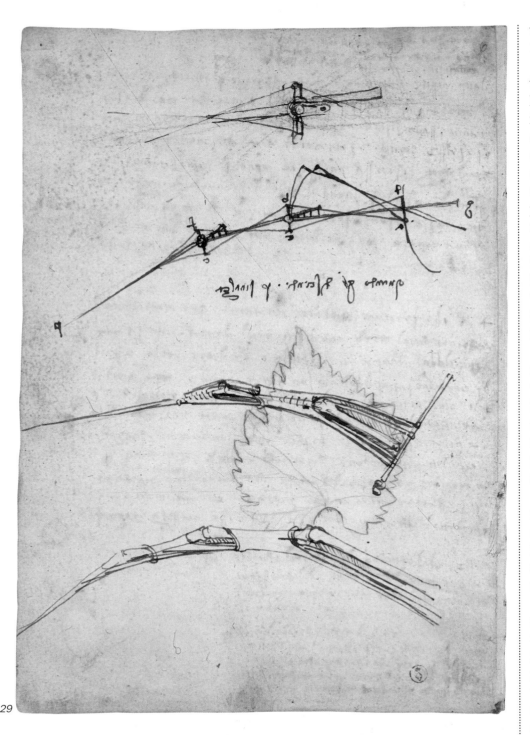

29 Studies for the
wings of the
machine (CV 11v).
The ones on the
bottom closely
resemble
the bone segments
of a natural wing.

29

work the *Battle of Anghiari* (ca. 1504-1506; fig. 32).

The preparatory studies made for this work (figs. 30, 33, 34) now lead Leonardo to concentrate his anatomical and psychological research not only on man, but on animals in general. His *de animalibus* research in comparative anatomy brings him even closer to the anatomical and psychological connections between man and animal affecting his studies on human flight. Leonardo's interest in the equilibrium movements made by birds recognises and studies their 'intelligence': their instinctive capacity to manoeuvre. He persists in this idea, calling it the bird's 'soul'.

Just as in other aspects of Leonardo's work, his research on flight involves the psychosomatic interaction between body and soul, a legacy passed down to Leonardo from the scholastic tradition of natural philosophy that he now develops in a new and original way.

As in pictorial imitation, one of his fundamental questions deals with *animatio*; the mental or emotional impulses and thoughts that humans and animals express through movements and 'body language'.

Leonardo confronts the problem of the soul in a similar way with regard to 'technical imitation': 'A bird is an instrument working according to the mathematics of natural law. It is within the capacity of man to reproduce all the movements of this instrument, but not with the same strength, being limited only to the

GUGLIELMO LIBRI
AND THE THEFT
OF THE CODEX
'ON THE FLIGHT OF BIRDS'

Napoleon ordered the Codex 'On the Flight of Birds', as well as many of the other manuscripts by Leonardo, to be brought to Paris. This, in fact, was the first theft of the Codex, at the time bound inside a larger codex by Leonardo, the Manuscript B.

In Paris over the course of the 1800s, Leonardo's codices attracted the attention of many scholars. Among these scholars was the Italian, Guglielmo Libri.

He was a scientist, a mathematician and a science historian of some note; a figure above all suspicion, who had no difficulty in obtaining permission in order to consult the valuable material by Leonardo.

But he did not stop at this: he removed various pages from the Manuscripts A and B, as well as extracting the entire Codex 'On the Flight of Birds' from Manuscript B.

There is also an hypothesis about the method Libri used to remove the pages without creating suspicion. It is believed that he used a string soaked in muriatic acid, leaving it in the codex as a bookmark.

Over the course of the night or a few days the acid ate away at the page and he could remove it without using knives or other, more suspicious tools.

Once he removed the pages, Libri sought a better form in which to sell them. He bound the pages taken from Manuscripts A and B into small leaflets, while the Codex 'On the Flight of Birds' was dismembered. All this was done, obviously, to hide the illegal origin of the material.

The Codex 'On the Flight of Birds' was dispersed, and five folios were bought in London becoming property of the bibliophile Charles Fairfax Murray. They eventually ended up in Geneva, in the collection of Henry Fatio. The other thirteen folios found their way into the hands of Theodore Sabachnikoff. He printed an edition of the Codex in 1893, an edition that was nevertheless incomplete.

Only around 1920, as a result of the efforts by the Reale Commissione Vinciana and the work done by Enrico Caruso, did the Italian government regain possession of the missing pages.

The Codex, returned to its original form, was placed in the Biblioteca Reale in Turin.

The Codex 'On the Flight of Birds' (f. 15 on the bottom) along with other manuscripts by Leonardo was transferred to Paris following Napoleon's orders (below in a portrait by Ingres) and kept in the Institute de France (lower right). It was from this building that during the 1800s, Guglielmo Libri stole the work. It was recovered much later, and turned over for keeping to the Biblioteca Reale in Turin.

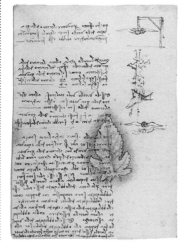

30 and 32 Preparatory drawing for the Battle of Anghiari (ca. 1505-1506; Venice, Accademia, no. 215 A) and an anonymous copy of the same image ("Tavola Doria").

31 Study of the mechanical wing (ca. 1505-1506; CA 434r).

33 Comparison between the expressions in man and in some animals (horse and lion) (ca. 1504-1506; W 12326r).

30

31

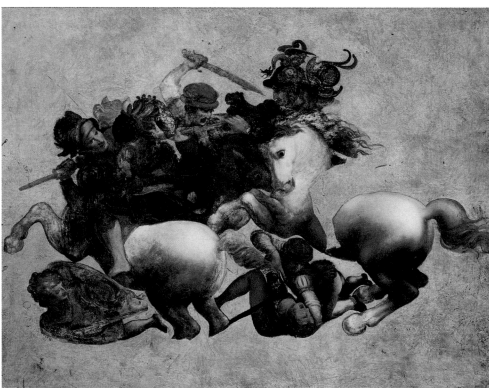

32

balancing movements. Thus it could be said that the instrument made by man is lacking only the *soul of the bird*, which must be counterfeited with the *soul of man*'. (CA 434r).

The last lines of this passage express the need, but also the limitations, placed on exact imitation of nature when the object to be imitated has a soul.

These lines can be compared with a section from Leonardo's *Treatise on Painting*, expressing an analogous difficulty in pictorial imitation: 'In which painting lacks nothing more that the soul of the imitated things' (ca. 1500-1505; §15).

In order to counterfeit the 'soul' of a real bird, Leonardo places a pilot in the 'bird' he copied from nature; not a protagonist or beneficiary of a new invention, but simply an element of the whole, even though more 'spiritual' in nature.

The pilot-soul projects dating from the period of Leonardo's first sojourn in Milan deal solely with force: the muscular force needed to lift the flying machine.

Later, during the same period of renewed interest in *de animalibus* anatomical research and an appreciation of the intelligence of animals, there is increased interest in soaring flight. The pilot-soul furnishes the manoeuvring skills needed to work the air currents: 'The limbs of a bird will certainly respond to the needs of its *soul* much better than those limbs responding to the *soul* of a man separated from them, and from

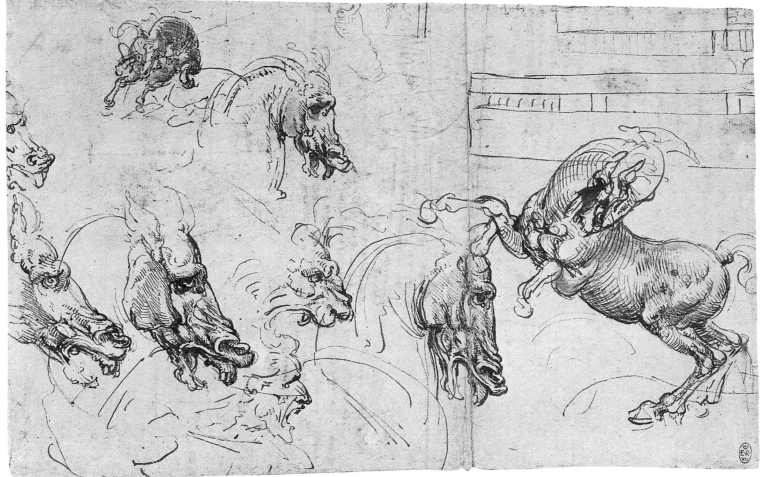

33

34 Study of
comparative
anatomy between
human legs
and horse legs
(ca. 1506-1508;
W 12625).

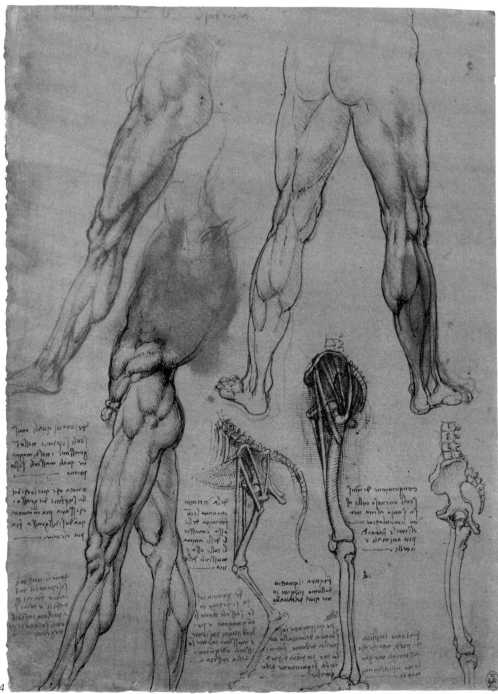

34

their almost imperceptible movements; but the many subtle movements we observe in birds, for the most part, can be learned by man and this will keep the machine, for which man is *soul and driver*, from crashing' (CA 434r).

The variety and subtlety in the movements required of the pilot-soul seem to be the technical equivalent of the various movements in painted figures needed to express the most subtle and imperceptible impulses of the soul.

Artistic *animatio* finds its rival in the search for technical *animatio*.

Thus, during the 1490s, the flying machine was the expression of unlimited faith in the dynamic potentialities of the human body. Now, Leonardo is convinced of the functional, and even psychological, anatomical proximity between man and animal.

His research on nature leads Leonardo to believe, perhaps even more strongly than before, that even the 'soul' of a bird and its instinct for using the winds can be emulated. His high ambitions, however, already conceal the seeds of doubt. Fresh from his impassioned studies on the flight of birds, Leonardo recognises the very subtle capabilities of birds to manoeuvre in the wind as implied in the last quotation.

The first line of the same passage expresses his increasing doubt in man's ability to truly imitate birds.

Some of the single pages currently in the Codex Atlanticus contain notes very similar to those in the Codex 'On the Flight of Birds'. Most of these folios are not well known and for reasons we will see, can all be dated to the same period (ca. 1503-1505). One of these is the folio 357r in the Codex Atlanticus. On the verso of the folio there is a note – not by Leonardo – indicating: 'Florence, April 1503'. On the recto, in the lower right corner, there is a sketch of the pilot in the flying machine that is very similar even in content to the drawing in the upper portion of folio 5r in the Codex 'On the Flight of Birds'. The note above this sketch deals with equilibrium in flight, the same topic dealt with in the latter: 'The man in the bird is positioned just a bit higher than his centre of gravity'. A drawing of the pilot in the machine, just as schematic and dating to the same period, is found in Manuscript L, f. 59r, below a sketch of the machine's tiller. The elliptical path seen just above this may also be connected to flight and should be approached relative to studies from the same period, such as those in Manuscript K^1, f. 13r and the Codex Atlanticus, f. 186v that date from the same period as Manuscript K and the Codex 'On the Flight of Birds'.

STUDIES ON FLIGHT IN THE CODEX ATLANTICUS

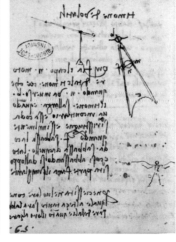

Sketches of the pilot inside the flying machine in CA 357r (detail, fig. top left) and in Manuscript L, f. 59r (fig. top right). Other lesser-known studies on flight in the Codex Atlanticus are reminiscent of the Codex

'On the Flight of Birds' (CA 186r, lower left and 202r, bottom; on the verso of the former there is the childhood memory analysed by Freud, on the verso of the latter there is a description of the Battle of Anghiari).

Going back to folio 357r in the Codex Atlanticus: the studies on statics representing scales (which cover the rest of the folio) are another topic connected to flight that bring us back to the Codex 'On the Flight of Birds'. The tone of the riddles inserted by Leonardo on the upper right of the page also reminds us of the latter. One of these riddles is entitled: 'On the bombards that come out of the ditch and on their form', and continues: 'It will come out from under the earth and with frightening cries will stun all around it and with its breath it will make men die and destroy cities and castles'. This prophetic tone is reminiscent of the Codex in the Turin library: 'The large bird's first flight will be on the back of the great Cècero'. Another folio in the Codex Atlanticus dating from the same period as the Codex 'On the Flight of Birds' is the folio 202r. On the verso there is the famous description of the Battle of Anghiari given to Leonardo in order to paint that specific episode in Florentine history. Some of the sketches of wings, visible in the centre and lower portions of the page, are very similar to those inserted on folio 11v and folio 7r of the Codex 'On the Flight of Birds' (cfr. figs. 19 and 29). Finally, from a graphic standpoint, folio 186 (especially folio 186r) has notes that are very close to the Turin Codex (the elliptical path on the verso was already mentioned). This is the folio with the famous childhood memory studied by Freud: 'This is about the black kite, which seems to be my destiny, because in the earliest memory of my childhood it seemed to me that, as I was lying in my cradle, a kite came down and opening my mouth with its tail, struck me many times with its tail inside my lips'. (CA 186v).

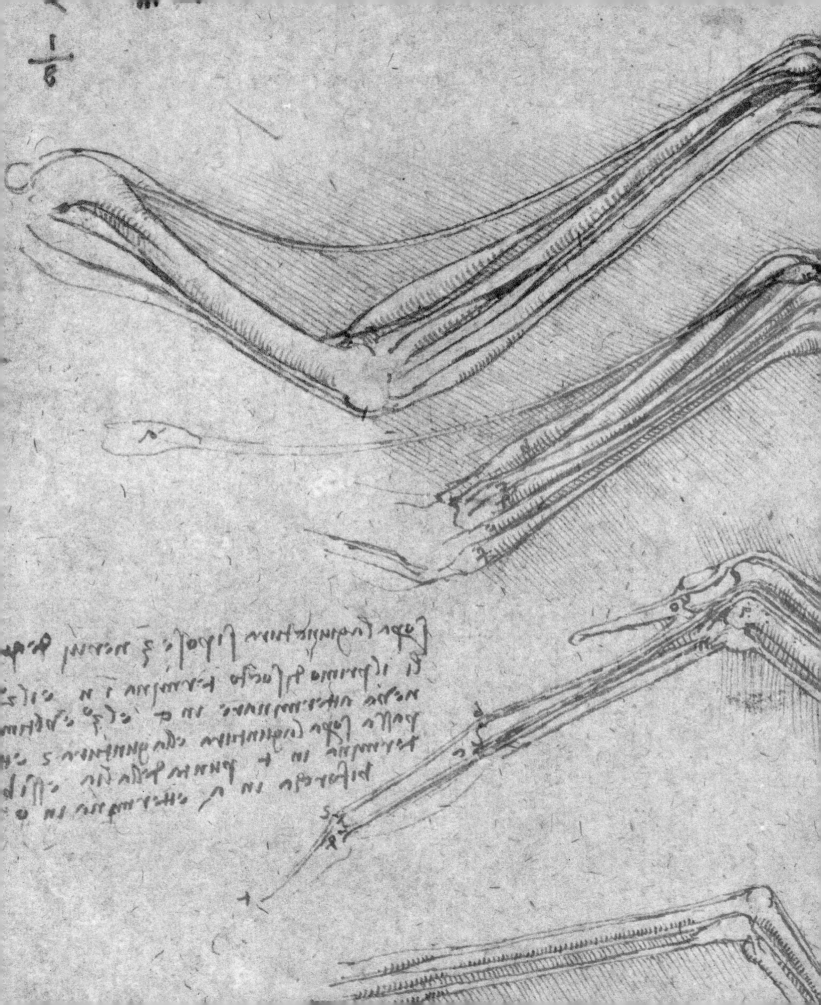

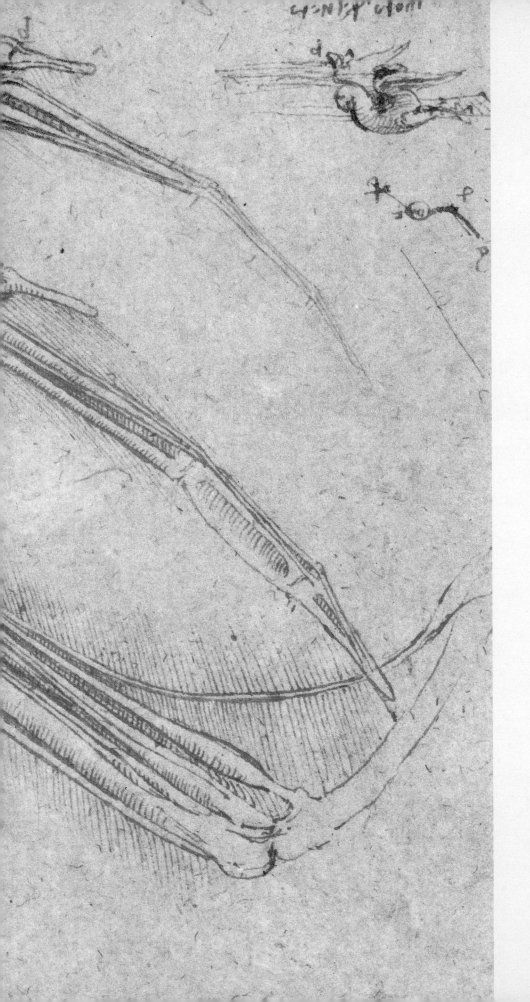

Even during the last years of his life Leonardo does not abandon the idea of human flight. Nonetheless, he totally immerses himself in theoretical studies. The constant osmosis between knowing and doing, typical of earlier years when theoretical conquests went hand-in-hand with field testing, is interrupted. During this last phase of his research Leonardo is interested in flight itself, and the conditions conducive to flight. In addition, during this last phase in his research, Leonardo works on a series of simple, amusing experiments, and entertains himself inventing mechanical contrivances. These are all related to flight and flying, and they seem to be pure and simple 'divertissements'; an escape into a world of amusement where Leonardo can overcome the delusion of a dream, which at times, he still pursues.

*1 Various types
of motion
(Ms. E 42r).*

*2 Deluge
(ca. 1513-1518;
W 12380).*

1

ON THE ERRORS OF THOSE WHO USE 'PRACTISE WITHOUT SCIENCE'

'Those who are enamoured of practise without science are like the helmsman who navigates without rudder and compass, never certain where he goes'; this reflection by Leonardo appears in Manuscript G, folio 8r.

Contrary to popular belief, Leonardo does not abandon the idea of human flight during the last years of his life, and he continues to consider the two types of flight: active flight from flapping wings and muscle force, and soaring flight, based on manoeuvres in the wind. Nonetheless, his work in this field becomes increasingly rare. His writings show that flight is dominated by theoretical and cognitive studies during his later life, lacking a practical component: the construction of the flying machine.

The notation in Manuscript G was written very late in Leonardo's life. We are in Rome, or most likely, Milan, between 1510 and 1515. He has left Florence; first in 1506, and then definitively in 1508. He gravitates between Rome and Milan until 1517, when upon the invitation of François I, he settles in France where he dies in 1519. In the passage quoted above, Leonardo distances himself from 'practical' knowledge, typical of the workshop experiences in both art and engineering that were the foundation of his youth in Florence; the environment where he received his training, and most certainly, where his first ideas on human flight were conceived. Now, theory – pure science – has mov-

2

3-5 Two opposite
concepts
of the deluge;
the forces of
nature dominate
Leonardo's concept
(ca. 1513-1518;
W 12376; fig. 4),

while man
dominates
in Michelangelo
(Sistine Chapel,
ca. 1509-1511;
figs. 3 and 5).

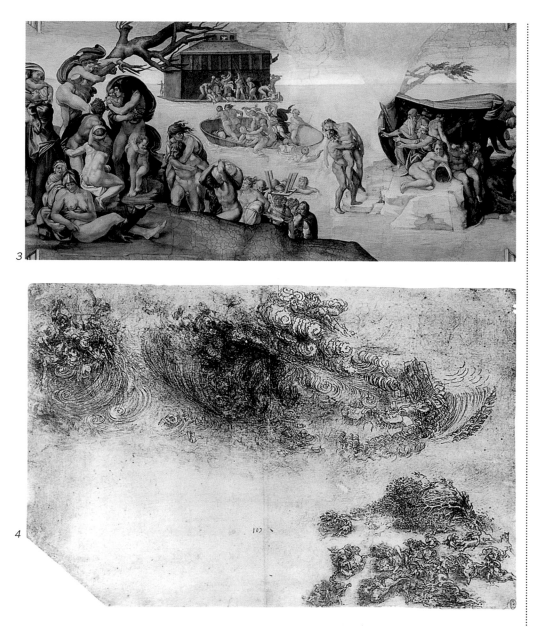

3

4

ed into first place. Numerous theoretical studies dedicated to wind, air and natural flight were made during this period. Relatively few studies deal with the 'practical' side of his research: the construction of the flying machine. Leonardo's thought pattern, a sort of alternating current – one direction for the understanding of nature, the other for the technical or artistic emulation of nature – now seems to be interrupted. His mind appears to stay with theory without switching back over to the practical side. Knowing no longer coincides with doing. The Renaissance is at the far turn, and its lead horse seems to be losing ground.

THE THEORETICAL STUDY OF WIND AND BIRDS

The section of Manuscript E dedicated to flight, compiled by Leonardo about 1513-1514, exemplifies the last phase of his studies on this subject. The titles of some of his notes catch our eye: 'theory of birds' (next to a note on the banking of birds in soaring flight, folio 50r), 'theoretics' (beside another note on turning during flapping flight, folio 50r), 'science', 'rule', are now the terms repeated alongside other notes and drawings (f. 49v). Even the first note opening the section on flight in this Manuscript proposes a similar program of study: 'To give true science to the movement of birds in air, it is necessary to first study the science of the winds, which we prove using the same movements in water, and this science will lead us

94

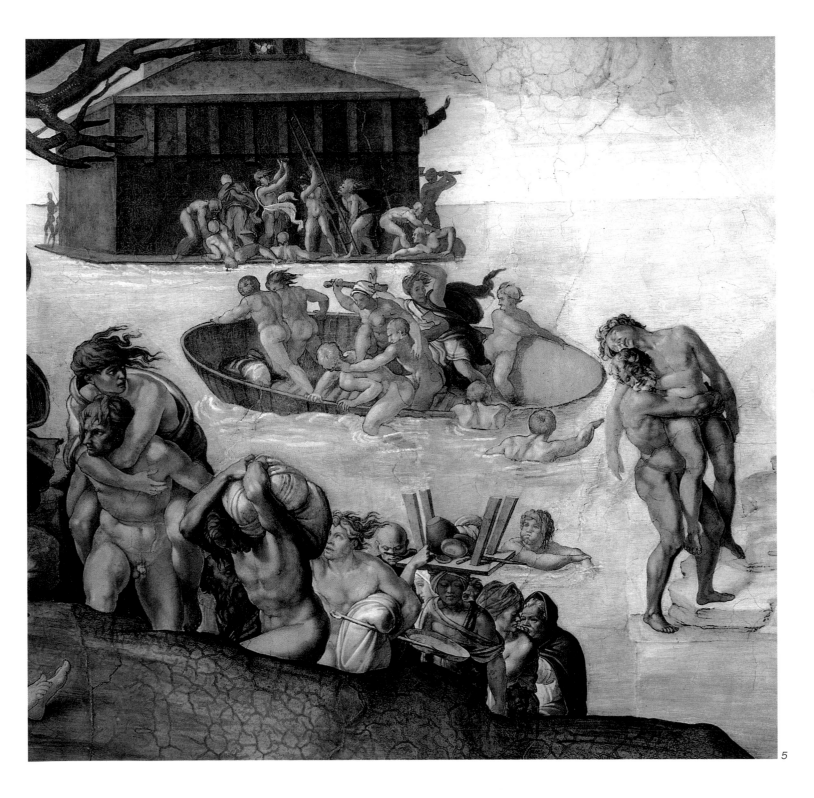

6 Study of different forms of hydraulic flow in the Codex Leister, f. 13B (13v-24r).

7 Study of hydraulic flows (ca. 1509; W 12660r, detail).

8 Meteorological study of the action of wind on clouds (Ms. G 91v).

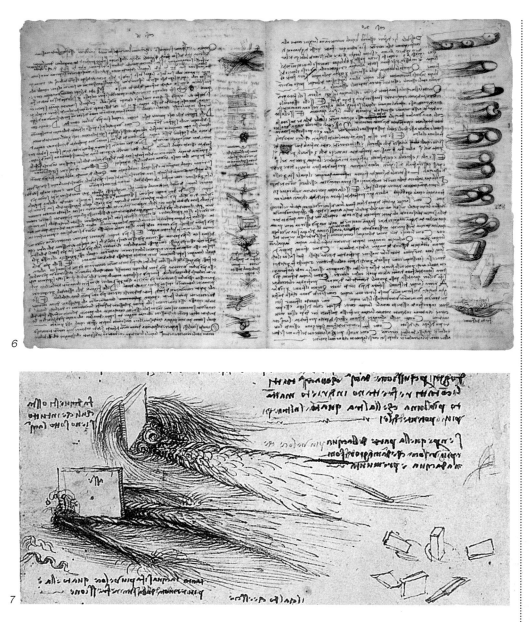

6

7

to knowledge about birds within the air and wind' (f. 54r).

In a very explicit manner, Leonardo states that the study of flight is an autonomous science; as with all scientific or theoretical knowledge, it is a field of research that is complete unto itself and does not necessarily require the immediate, practical application of a flying machine. Knowledge does not necessarily mean doing. In the Codex 'On the Flight of Birds' the theoretical section on natural flight is followed immediately by a practical section, applying the theory to the flying machine. In Manuscript E, however, there are only a few brief allusions to artificial flight, or, 'instrumental' flight as Leonardo defines it. Increasingly theoretical subjects prevail. In the midst of his notes on flight he inserts a folio with a general analysis of the different forms of motion: direct, curved, 'composite', spiral (42r; fig. 1).

THE 'SCIENCE OF THE WINDS'

One of the most apparent aspects of Leonardo's late artistic and scientific work is his change of focus from man to the natural environment: the elements – especially water and air – are now the protagonists. The way natural phenomena occur and how nature's creatures live within nature become more important than the creatures themselves, man included. On the artistic side, one simply needs to compare the drawings of *Deluge* (figs. 2 and 4), made by Leonardo at about the time of Manuscript E, with the

9 CA 205r: drawing of the universe with the spheres of elements (top right).

10 Study of the relationship between a bird's wing and air pressure (Ms. E 47v).

frescoed scenes by Michelangelo on the vault of the Sistine Chapel (figs. 3 and 5), dating from a short period before (ca. 1509-1511). In the former, there is an 'all-encompassing' vision and the natural elements overwhelm any human presence. The latter focuses in on man, the overwhelming figure in a nature represented by a few scanty landscapes.

On the scientific side, Leonardo's new viewpoint already appears in the Codex Leicester (ca. 1506-1510; fig. 6), a work entirely dedicated to the study of water and land. This codex contains a new concept of the optical interference by air and its density in transmitting images to the eye. The undefined, 'out of focus' contour, the famous *sfumato* in the paintings by Leonardo that overturns the sharp, mathematical vision of *Quattrocento* perspective, stems from this concept. His studies on flight are another, clear example of this more generalised vision.

For the most part, Leonardo concentrates his studies on the 'science of winds' in Manuscript E. The work alludes to a problem connected with this study, while at the same time furnishing the solution. Air, the winds, are invisible and therefore studying them certainly becomes problematic with respect to water. Previously, Leonardo had constructed anemometers in order to 'visualise' and measure wind (CA 675 and Arundel 241r) and hygrometers for measuring the 'density' of the air. Leonardo now proposes the systematic analysis of

9

air current dynamics, analogous to what he had already carried out on water flow, demonstrating its multitude of configurations in various states and layers (for example, water cascading over a cliff, water breaking against an object; figs. 6 and 7). The solution Leonardo proposes for an equivalent study on the 'science of the winds' is to use the motion of water in itself, as an analogy for the wind. The use of analogy in his studies is now found principally in relation to the animal world: birds fly in air the way fish swim in water, is now directed towards the elements in which animals move.

The following thoughts, expressed as an analogy, appear on folio 54r (cited above) of Manuscript E: after wind passes through the mountains tops, it opens and freely expands, similar to water after rushing through a fast narrow passage, and expanding into a large, calm basin it becomes slower and less dense. 'The wind in passing through the heights of mountains becomes fast and dense, and when it emerges is slower and less dense, similar to water that flows from a narrow canal into a wide sea'.

Leonardo also broadens his scope of studies to include geographical and meteorological elements. In his other studies, Leonardo comments on the way wind is formed; he examines the way in which air condenses into water when the temperature changes (or vice versa), thus causing the precipitation of the air into the surrounding void; he studies the action

10

11 Study of the wind
by observing
the behaviour
of birds
near sea cliffs
(Ms. E 42v, detail).

12 Study of wind
currents
by observing
the flight paths
of birds
(Ms. E 54r).

11

of the wind on clouds (G 91v; fig. 8) and from a broader, cosmographical aspect, also analyses how air becomes thinner as it approaches the sphere of fire.

Leonardo adhered, in part, to an Aristotelian view of the universe. The elements on earth formed spheres, (at least in a virtual sense, because their movement caused a constant combination of the four elements): the sphere of fire was in the highest position; bordering on this was the sphere of air, then water and at the lowest, most central point, the earth.

A drawing in the Codex Atlanticus (205r) depicts this cosmological configuration (fig. 9).

It is nonetheless unique that the hypothesis on the thinness of the air at high altitudes, affirmed by Leonardo in earlier studies (M 43r and 43v), is now proven in Manuscript E by watching birds in flight: 'Because the small birds do not fly at great heights, nor do the large ones enjoy flying low. This is because the small birds, having few feathers can not stand the immense cold at the upper heights of the air, as can the vultures and the eagles and other birds covered with many layers of feathers; the small birds have weak, single-layered wings that keep them aflight in this low air, which is dense, and they would not keep them aflight nor resist long in the thin air' (43r).

Only the large birds of prey, and not the small birds, fly in the upper air. Due to the reduced wingspan of the smaller birds, the upper air is too

thin to keep them in flight. Like water, birds seem to be yet another 'expedient' for understanding the otherwise invisible air currents. But only an expedient. At times, when Leonardo is studying the movements of birds, it seems his real objective is something else: to use them to understand the workings of air. Just as Leonardo placed obstacles in the streams to study water currents, birds are natural obstacles reacting to the variation in the air currents.

One of the fundamental principles in his 'science of the winds' is the capacity to compress air. Unlike water, if air is 'squeezed' sufficiently (as in a wingbeat) it can be compressed: 'Air can be compressed and thinned almost infinitely' (E 47v). In this very same folio (fig. 10) there is a drawing of a bird wing that seems to confirm this postulate. The curvature of the wing, especially at the terminal feathers, is directly connected to the curvature of the air underneath it.

The analysis is made with a clarity not found in any of the other drawings in the Codex 'On the Flight of Birds', and he draws in the lines of centripetal force that press the wing to curve. In another study (E 42v; fig. 11), Leonardo observes that with their wings spread some birds can remain stopped in mid-air near sea cliffs. He deduces that at these points the wind hits against the cliff and is reflected up, forming the ascending currents supporting the bird. In another example of the study of aerodynamics by analogy, the bird seems

12

13-14 Study of the change in flight path in function of wind direction (Ms. E 40r and 40v).

13

to float upon the air currents as if it were on the water below. Finally, the rapid deviation of a bird's course of flight indicates the presence of two wind currents coming from different directions (E 54r; fig. 12).

'DE' VOLATILI':
FLIGHT, ANATOMY, ETHOLOGY

Leonardo studies birds not only in terms of the 'science of the winds'; they are also subject of an in-depth, autonomous study. *De' volatili* is the latinized title that introduces many passages in Manuscript E dedicated to this subject.

Three main topics are involved in this study: movement in flight, anatomy, ethology. The first topic is an extension of what has already been discussed: equilibrium manoeuvres in flight, wingbeats, how a bird's velocity and altitude vary as a function of the wind (E 40r and 40v; figs. 13, 14). One of the other study topics is anatomy. Leonardo's most beautiful and complete anatomical studies date from about 1513 (W 12656 and 19107; figs. 15, 17). While the first topic deals with the flight of birds, here, Leonardo attempts to discover the anatomical factors behind their movements. Previous anatomical studies on the wing where part of his project for the mechanical wing, however the later anatomical studies seem to be purely scientific: the anatomical verification of the functioning of living birds during flight.

Windsor folio 12656 (fig. 15) contains careful anatomical studies, and

15-16 The anatomy
of a bird's wing
undergoes careful
study (ca. 1513;
W 12656r; fig. 15),
similar to that
of a human arm
(ca. 1509-1510;
W 19000v; fig. 16).

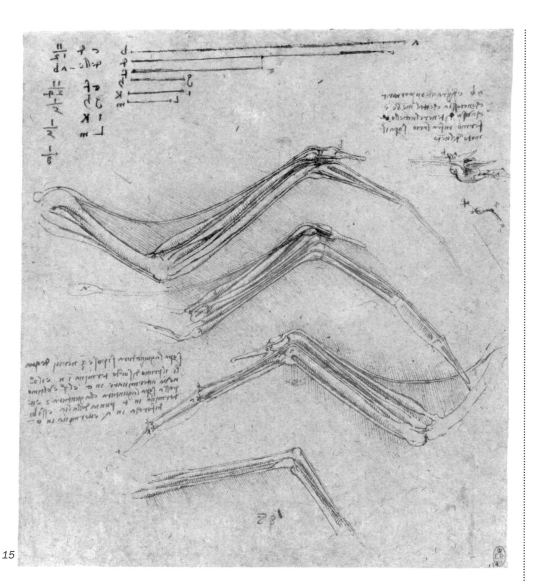

15

the various drawings show the same accuracy and level of completion as those dedicated to the anatomical study of human arms dating from a few years earlier (ca. 1510; fig. 16).

Further, the Windsor drawings make explicit comparisons between man and bird. The topics that now occupy Leonardo's studies are part of a vaster research project on *de animalibus* anatomical research: man in relation to the other animals, a topic that gradually filled Leonardo's thoughts. From a strictly anatomical point of view, the alula, or bastard wing is an element not included in previous studies.

This small, wing-like structure above the third wing joint is depicted as if it were a type of claw; in the written notes, it is often compared to the thumb of a hand.

As stated, the reasons for Leonardo's current anatomical analyses are purely functional, and the drawing shows how the *alula* keeps the bird hovering in mid-air.

During Leonardo's studies on flight, the *alula* is examined as a rudder used in cutting through the air when the edge placed into the wind, or, used to forceably compress the air underneath the wing if opened into the wind, thereby keeping the bird stationary.

The *alula* also appears in another anatomical study (fig. 17). But this study seems to concentrate on a different function: sustaining flight using the wingtips. The wingtips form a continuous surface capable of com-

pressing the air. The note accompanying this illustration in fact, shows the flexion-extension function of the feathers.

The final frontier in Leonardo's study of birds is ethological in nature, and his studies on the flight of various insects and bats appear on some of the folios in Manuscript G. Ever since his youth (and as regards the bat, even afterwards), Leonardo studied these animals in relation the flying machine.

Now, he studies them for themselves, and he investigates the natural causes behind certain flight techniques, introducing ethological notes that are now completely unrelated to artificial flight.

He affirms that the continuous covering, or membrane, on bat wings is the only system that can allow for this animal's daring flight manoeuvres (G 63v; fig. 18).

Leonardo studies the 'Flight of the fourth species of moths, eaters of the winged ants' (G 64v; fig. 19), known more commonly as ant-lions, using an analogous system. Beetles are included in some of these studies, and Leonardo observes that only one of the pairs of beetle wing seems to be used for flight, the other pair probably serving as protection or a covering for the first (G 92r; fig. 20).

He also studies the fly, which beats its wings with such 'velocity and sound', (the 'buzz') that he stays stationary in the air, using his hind legs as a rudder (G 92r).

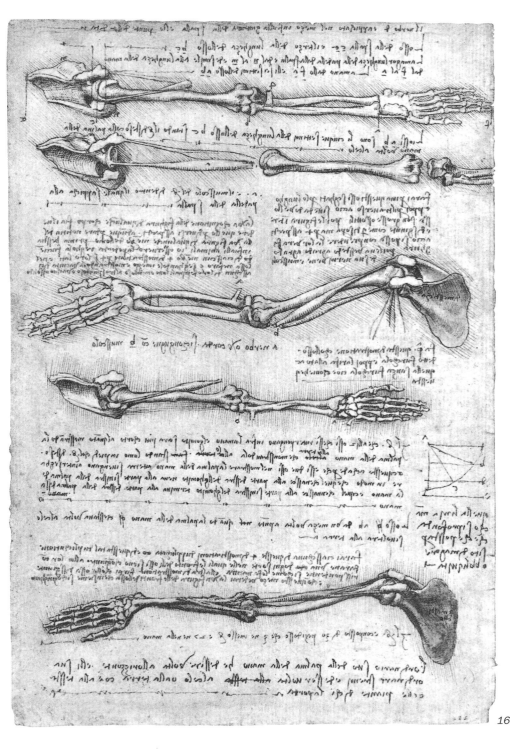

16

17 Anatomy
 of the wing
 (ca. 1513;
 W 19017).

18 Study of birds
 and bats
 (Ms. G 63v).

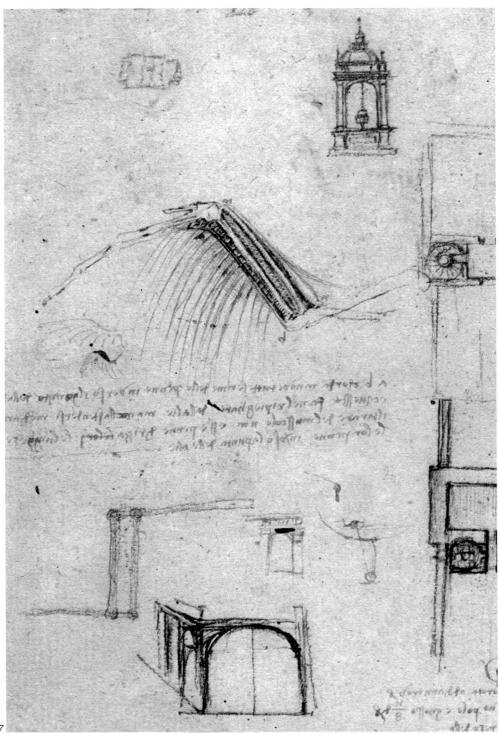

17

HUMAN FLIGHT.
THE LAST MENTION OF THE FLYING MACHINE AND FLAPPING FLIGHT

In the midst of the theoretical studies dedicated to the movements of birds in flight in Manuscript E, at least at one point, Leonardo's mind seems to leave the realm of pure knowledge and venture towards the mechanical imitation of the natural flight of birds. In some of the notes on folio 44v describing the behaviour of birds the topic seems to veer from the realm of knowing to that of doing by imitation.

Leonardo talks about the inherent danger in this practical application, addressing himself in the second person, or, giving instructions to the machine's pilot, just as he did in the Codex 'On the Flight of Birds': 'So, in this way, you would automatically extend the folded wing towards the ground and at the same time bring back the lower, spread wing, until you return to a point of equilibrium'. This is, however, a fleeting thought. There is no drawing on the folio or in Manuscript E referring to a mechanical wing and its articulated manoeuvres. One of the Windsor folios dating from about 1513-1514, contains a small sketch of the anatomy of a wing made up of four bone segments moved by tendons, one of which passes through a fibrous ring (19086r; figs. 21-22).

As in previous instances, it is not clear whether here the drawing represents a natural or artificial wing. What is certain however, is during his later years, Leonardo continues

to think about mechanical flight. A note relating to the theoretical analysis of natural flight on folio 124r of the Codex Atlanticus, specifically refers to flapping in artificial flight: 'You will show the anatomy of a bird's wing along with the chest muscles that drive these wings. And you will do the same for man to show how he can keep himself in the air with flapping wings'.

In another folio from the same codex (1047r; fig. 23) dating from the same period as the previous folio (1513-1515, the period in Rome), Leonardo draws the flying machine and, in one instance, also the pilot.

Perhaps it is a project for an ornithopter where the wings are attached directly to the pilot's arms. If this interpretation is correct, then it makes sense to also look at a study in Anatomia A (ca. 1510; W 19011v; fig. 24), where the muscles responsible for the movements in the human arm are compared to those that move a bird's wing: 'No movement in the hand or the fingers can be made without using muscles from above the elbow. And thus so for birds, and all the power in the muscles used for flapping begins in the breast, which weighs more than all the rest of the bird'. A bird's pectoral muscles are used for flapping, the same movement Leonardo is trying to imitate with the flying machine. One of his drawings shows an arm holding a long pole, in a very similar manner to the pilot of the 'ornithopter' on folio 1047r in the Codex Atlanticus.

18

*19-20 Study of
flying insects
(Ms. G 64v and 92r).*

19

HUMAN FLIGHT AS OBJECTS FALLING IN THE AIR

The same folio of the Codex Atlanticus contains a note on bodies falling in the air: 'Tomorrow make figures from cardboard in various forms descending in the air, falling from our wharf. And then draw the figures and the movements they make in each stage of the descent'.

In addition to the studies on flight equilibrium manoeuvres and flapping flight, Leonardo's research into artificial flight in this period also includes the study of aerostatics. Two notes analyse human flight from different perspectives.

Here, Leonardo's reflections do not stem from the anatomy and the workings of birds, but from the physics of air as an element, and the general static-dynamic behaviour of bodies in the air. 'On things falling in air' (G 74r), 'Various figures of insensitive bodies descending by themselves in the air' (W 12657); these titles or 'introductions' also apply to human flight.

Like birds, man is only one of the elements in the more general study of aerodynamics of 'insensitive' or inanimate weights or bodies; bodies without souls and therefore incapable of voluntary motion, which 'descend by themselves', without will or instinct.

In these two notes on human flight, one of them is based on the observation of birds, but only as regards the more general principle of aerostatics that are applied to man: 'The bird

21-22 Full view and
detail for the study
of the segments
in a natural or
mechanical wing
(ca. 1513-1514;
W 19086r).

23 Study of
a pilot with
mechanical wings
(ca. 1513-1515;
CA 1047r, detail).

21

22

gains altitude the more it opens and spreads its wings and tail. A body becomes lighter the more it extends in size. This leads to the conclusion that man's weight could be supported in air by means of a very wide wingspan' (E 39r).

By spreading open its wings and tail, a bird becomes lighter; it becomes heavier closing it. In fact, a bird folds its tail and pulls in its wings when it wants to accelerate in descent. This law is common to all bodies and is therefore applicable to man who, if suspended from a sufficiently large support apparatus, can keep himself aloft.

Even though Leonardo still uses the term 'wings', it is not in relation to the 'bird' flying machine.

In fact, it is in his other note on human flight appearing in Manuscript G (ca. 1510-1515; 74r; fig. 25) where Leonardo studies and illustrates a man suspended from a plank. It is worth noting that this entry makes no mention of the animal world.

Leonardo opens his reflections with the aerostatic and aerodynamic study of an 'insensitive' object such as a plank. His reasoning is based on statics and physics: when a curved sheet of paper or a plank descends through the air, the underside of the object exerts a downward pressure on the air.

The air is compressed, while the air above and on the sides becomes lighter, and the underside of the object gets greater support from the air, therefore becoming lighter in re-

24-25 Human
anatomy and a note
comparing dynamic
capacity in man
and birds
(one of the arms
is reminiscent
of the grip on the
mechanical wing,
ca. 1509-1510;

W 19011v;
fig. 24). This note
demonstrates
that in this period,
even though
sporadically,
Leonardo continues
to plan human flight
using flapping
wings.

Aerostatics
was also studied,
demonstrated
by the study
of a man
descending
in air suspended
from a plank
(Ms. G 74r;
fig. 25).

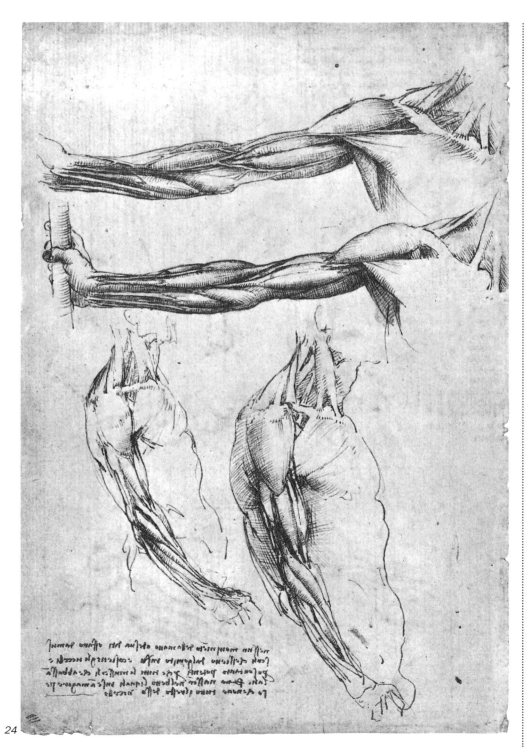

24

lation to the upper side. This side in turn dips downward, creating the typical zigzag descent of the sheet or the plank. It is this broader flight path, with respect to a vertical descent, that makes for a softer landing.

A man hanging from a board and tilting it first to the left and then the right, could in this way descend more slowly through the air.

Here we have an application that is simpler, but at the same time, subtler with respect to the project designs from the first period in Milan on descent using parachutes, spheres or kites.

AN AMUSING CONCLUSION AND SOME SHORT-CUTS

Giorgio Vasari recounts that when Leonardo was in Rome, guest at the Vatican (ca. 1513-1516), with a 'paste made out of a certain kind of wax... [he] made some light and billowy figures in the form of animals and blowing into them, he made them fly through the air'.

Vasari adds that he 'used to get the intestines of a bullock scraped completely free of their fat [...] and inflating them they filled the room, which was enormous'.

Instead of machines capable of imitating birds, the things that entertained Leonardo during this period consisted in flying wax figurines and intestines filled with air. 'He perpetrated hundreds of these follies', adds Giorgio Vasari.

Just as with his escape into theory and his diminished interest in me-

26 Drawing of a flying automaton in the form of a bird (ca. 1508; CA 231av, top).

26

chanical projects, Leonardo also adds this playful dimension to his experiments.

Nonetheless, even these games seem to have a more profound, personal sense than just a pastime to occasionally entertain at court. For similar court amusements, even when Leonardo uses more technically complicated flying devices – such as the automatons – the situation remains unaltered.

The 'automaton' mechanical bird, designed around 1508 on a folio in the Codex Atlanticus (629bv; fig. 26), descended on a rope and flapped its wings, with the help of an internal mechanism.

This and similar designs were obvious 'short cuts' with respect to the flying machine that imitated even the movements of a real bird, the machine that could really fly and like the bird, had a 'soul' in the form of a pilot.

Even Giovan Paolo Lomazzo writes about these flying automatons and other contraptions Leonardo put together during his later years: 'Leonardo […] taught how birds fly, how to make lions go in a ring and constructed monstrous animals. He used a certain material for birds that flew through the air, and once for François I King of France, he constructed a lion, a masterpiece in automation, that walked into a room and came to a halt, and opened its chest filled with lilies and all different kinds of flowers' (*Idea del tempio della pittura*, 1590).

After Leonardo, the interest in human flight increases enormously during the late 1800s and early 1900s. During this period pioneers such as Otto Lilienthal (1848-1896) and Pierre Louis Mouillard (1834-1897) are at work.

Also at this time there is the crowning success of the brothers Wilbur and Orville Wright (1867-1912 and 1871-1948). In 1903, the Wright Brothers succeed in flying an aeroplane driven with a combustion engine. The age of modern aeronautics is launched.

Did Leonardo's work play any role – direct or indirect – in this final process? The answer to this question is more complex than it would seem.

It is true that at the end of the 1800s in the midst of the study on human flight, the Codex 'On the Flight of Birds' was first published in 1893

LEONARDO
AND MODERN FLIGHT

(even though it was incomplete and missing a few pages). Lilienthal, Mouillard and Marey conceive of human flight in a sense that is very similar to that of Leonardo: they believe it should be an imitation of natural bird flight. Their works are filled with observations on natural flight and its laws; their flying machines are conceived for the most part for soaring flight in the wind.

Knowledge of Leonardo's ideas by these individuals – the Wrights included – is an open and intriguing problem, and as mentioned, Leonardo's Codex 'On the Flight of Birds'

is published in printed form for the first time during this period.

Nonetheless, even in light of these coincidences, the very great differences in flight as conceived by Leonardo and flight in modern terms should be stressed.

Modern flight with motor propulsion, inaugurated by the Wright Brothers in 1903, completely abandons the idea of flight imitating nature.

This is a very important difference with respect to Leonardo's concept, a difference that that marks the end of an era. It is certainly not a coincidence that during these years,

the figurative arts (cubism comes to mind) renounces the imitation of reality.

Leonardo might certainly be awed in front of a modern jet, but at the same time he would probably be a bit disillusioned. The rigid wings (not flexible and jointed like birds in nature) and an automatic motor mechanism inside the structure would most likely seem to him to be unacceptable shortcuts with respect to flight imitating nature; the only type of flight he deemed worthy of pursuit.

The Wright Brothers' flying machine, Washington, D.C., Smithsonian Institution's National Air and Space Museum.

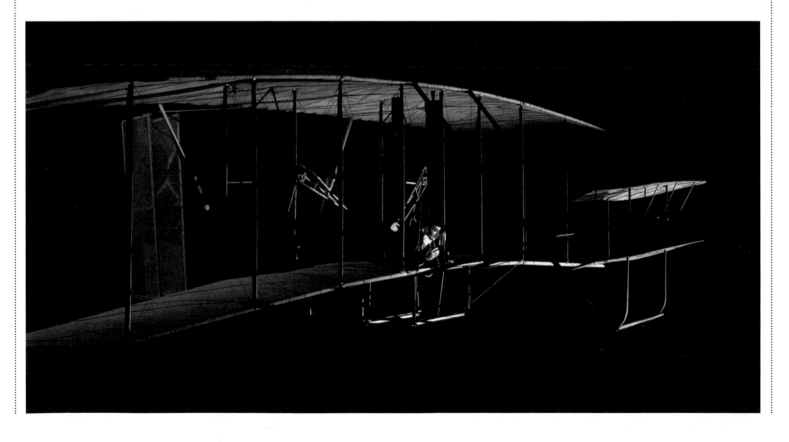

*27-28 Man with wings
attached to the
shoulders
and other studies
(ca. 1508-1510;
W 12724r
and CA 166r).*

27

Similarly there are also drawings depicting a man with either wings (W 12724r; fig. 27. Cfr. also W 12506) or a large cloak on his shoulders (CA 166r; fig. 28), jumping as if from a height.

For the most part, these drawing can be dated to about 1508-1510, and perhaps they too, were designed as projects for festivals or theatrical productions. Devoid of any technical-mechanical notions, their fantastical, theatrical nature is clearly evident.

The wings on the ornithopter on folio 1047r of the Codex Atlanticus are also attached directly onto the pilot's body, and it is logical to question whether perhaps this device was also meant for a theatrical production.

In all there instances, Leonardo seems to return to the starting point: the theatrical inventions, like those made during his youth in Florence, projects for human flight of the 'ornithopter-type' recalling the mythological dream, like Daedalus carved on Giotto's Bell Tower mentioned in the first chapter.

The circle seems to close at its beginning. Leonardo undertook a long journey in his search to understand nature in his attempt to re-create it. In the end, he did not succeed.

Nonetheless, these ludic and theatrical projects on human flight are not the same as those from his youth, and the optimistic emphasis of the earlier ones now passes to a more melancholic sense of escape

into a fantastical, literary realm. This interpretation seems to be confirmed by a section (ca. 1508-1510) that may contain the hint of a real crisis: 'Navigation is not an exact science because if it were, every danger could be avoided, like the birds that soar on the fortune of the winds […] and the fish that swim without perishing in the rivers and the seas' (W 12666r).

The ships man uses to imitate fish will never be able to equal the 'natural' ability with which fish and birds overcome every atmospheric storm. Even though not stated explicitly, Leonardo da Vinci thinks of the flying machine as 'navigating the air', the manner in which man can imitate birds.

This type of navigation and the technical imitation of nature seems to Leonardo to be utterly 'imperfect' and inadequate.

In his attempts to anatomically recreate a bird's wing, he marvels at the thought that nature always responds with forms that are perfectly suited for a given function ('Marvellous use of the directional power in wings'; W 12657).

However, his attempt to technically stay abreast of nature, also causes his despair.

Thus, in addition to the scarcity of studies for the flying machine, it is not surprising to discover that Leonardo's final period of research on the practical applications of the 'science of winds' is characterised by amusements, fantasy and theatrics.

28

117

BIBLIOGRAPHY

All the codices by Leonardo are published in facsimile by Giunti Editore, Florence, under the auspices of the Commissione Vinciana for the Edizione nazionale dei manoscritti e dei disegni di Leonardo da Vinci.

G. CARDANO, *De Subtilitate*, Nurimberg 1550, p. 317.

P. BOAYSTUAU, *De hominis excellentia*, Antwerp 1589, p. 239.

G. UZIELLI, *Descrizione del codice di Leonardo da Vinci relativo al volo degli uccelli appartente al conte Giacomo Manzoni di Lugo*, in *Ricerche intorno a Leonardo da Vinci. Serie seconda*, Rome 1884, pp. 389-412.

H. DE VILLENEUVE, *Léonard de Vinci aviateur*, "L'Aéronaute", Paris September 1874.

G. GOVI, *Sur une très ancienne application de l'hélice comme organ de propulsion*, "Comptes rendus hebdomadaires des séances de l'Académie des sciences", XCIII, Paris 1881, pp. 400-402.

P. AMANS, *La physiologie du vol d'après Léonard de Vinci*, "Revue scientifique", XLIX, Paris 1892, pp. 687-693.

C. BUTTENSTEDT, *Leonardo da Vinci's Flugtheorie*, "Die Welt der Technik", Berlin 1907.

P. RAVIGNEAUX, *Léonard de Vinci (1452-1513 [sic]) et l'aviation*, "La vie automobile", VIII, Paris 1908.

L. BELTRAMI, *L'aeroplano di Leonardo*, in *Leonardo da Vinci. Conferenze fiorentine*, Florence 1910, pp. 315-326.

E. MC CURDY, *Leonardo da Vinci and the science of flight*, "The nineteenth Century and after", XIX-XX, London 1910, pp. 126-142.

O. SIRÉN, *Leonardo da Vincis Studier rörande Flygproblemet*, "Särtrysck ur nordisk Tidskrift", 5, Stockholm 1910.

L. BELTRAMI, *Leonardo da Vinci e l'aviazione*, Milan 1912.

H. DONALIES, *Leonardo da Vinci's Flugtheorie*, "Deutsche Luftfahrer Zeitschrift", XVI, Berlin 1912.

S. DE RICCI, *Les feuillets perdus du manuscrit de Léonard de Vinci sur le vol des oiseaux*, "Mélanges Picot", extract, Paris 1913.

R. GIACOMELLI, *Gli studi di Leonardo da Vinci sul volo*, "L'aeronauta", II, Rome 1919.

G. BOFFITO, *Due passi del Cardano concernenti Leonardo da Vinci e l'aviazione*, "Atti della Reale Accademia delle scienze di Torino", Turin 1920.

G. BOFFITO, *I voli di Dante Alighieri e di Leonardo da Vinci*, in *Il volo in Italia: storia documentata e aneddotica dell'aeronautica e dell'aviazione in Italia*, Florence 1921 pp. 58-71.

F. J. HASKIN, *Leonardo and his Wings*, "The Springfield Union", 26, X, New York 1921.

G. DE TONI, *Gli studi sul volo*, in *Le piante e gli animali in Leonardo da Vinci*, Bologna 1922, 129-142.

B. HART IVOR, *Leonardo da Vinci as a pioneer of aviation*, "The Journal of the Royal aeronautical Society", XXVII, London 1923, pp. 244-269.

B. HART IVOR, *Leonardo da Vinci as a Pioneer of Aviation*, in *The mechanical Investigations of Leonardo da Vinci*, London 1925, pp. 143-193.

R. GIACOMELLI, *La forma di migliore penetrazione secondo Leonardo*, "Atti della prima settimana aerotecnica", Rome 1925; extracts, Pisa 1925.

R. MARCOLONGO, *I centri di gravità dei corpi negli scritti di Leonardo*, "Raccolta Vinciana", 13, Milan 1926-1929, pp. 99-113.

G. BILANCIONI, *Le leggi del volo negli uccelli secondo Leonardo*, "L'Aerotecnica", Pisa 1927.

R. GIACOMELLI, *Leonardo da Vinci e il volo meccanico*, "L'Aerotecnica", VI, Pisa 1927, pp. 486-524.

R. GIACOMELLI, *Il volo degli uccelli in due recenti pubblicazioni vinciane*, "Rivista di aeronautica", III, Rome 1927.

R. GIACOMELLI, *Dispositivi per il controllo laterale e l'aumento della portanza nell'ala dell'aeroplano e dell'uccello*, "L'aerotecnica", VI, Pisa 1927, pp. 40-58.

R. MARCOLONGO, *Le invenzioni di Leonardo da Vinci. Parte prima, Opere idrauliche, aviazione*, "Scientia", 41, 180, Milan 1927, pp. 245-254.

G. BILANCIONI, *Svolgimento storico del concetto di aria*, "Annali delle Università toscane", XI, Pisa 1928, pp. 107-171.

R. GIACOMELLI, *Les machines volantes de Léonard de Vinci et le vol à voile*, Extr. du tome 3 des *Comptes rendus du 4.ᵐᵉ Congrès de navigation aérienne tenu à Rome du 24 au 29 octobre 1927*, Rome 1928.

G. MORMINO, *Leonardo da Vinci e il volo*, "Rassegna nazionale", II, Rome 1928, pp. 177-182.

E. VERGA, *Recensioni agli studi di R. Giacomelli 1919, 1925, 1927[1-4], 1928*, "Raccolta Vinciana", XIII, Milan 1926-1929 (1930), pp. 156-163.

G. BILANCIONI, *Leonardo e Cardano*, "Rivista di Storia delle Scienze Mediche e Naturali", XXI, Rome 1930, pp. 4-30, in particular pp. 20-25.

R. GIACOMELLI, *The aerodynamics of Leonardo da Vinci*, "The Journal of the Royal Aeronautical Society", XXXIV, 1930, pp. 1016-1038.

R. GIACOMELLI, *I modelli delle macchine volanti di Leonardo da Vinci*, "L'Ingegnere", V, 1931, pp. 74-83.

R. GIACOMELLI, *Il terreno scelto da Leonardo per il volo a vela*, "Aeronautica", Rome 1931.

G. MORMINO, *Il precursore dell'aviazione mondiale: Leonardo da Vinci*, "Almanacco aeronautico", Milan 1931, pp. 13-19.

Esposizione dell'aeronautica italiana, catalogue, Milan 1934.

R. GIACOMELLI, *Progetti vinciani di macchine volanti all'Esposizione aeronautica di Milano*, "L'aeronautica", 14, Rome 1934, 8-9, pp. 1047-1065.

R. GIACOMELLI, *Gli scritti di Leonardo da Vinci sul volo*, Rome 1936.

A. DATTRINO, *Il volo a vela e il volo muscolare*, Turin 1938.

R. GIACOMELLI, *Leonardo da Vinci e il problema del volo*, «Sapere», Milan 1938, pp. 404-408.

AA. VV., "Ala d'Italia", XX, Rome 1939, special issue dedicated to Leonardo.

G. MORMINO, *Storia dell'aeronautica dai miti antichissimi ai nostri giorni*, Milan 1939.

R. GIACOMELLI, *Leonardo da Vinci e Francesco Lana: i due primi assertori del volo in base a considerazioni fisiche e Giovanni Alfonso Borelli e la prima critica razionale su basi quantitative dei sistemi per volare*, in "Atti della XXVII riunione della SIPS [Società italiana per il progresso delle scienze]" (Bologna 1938), Rome 1939.

R. GIACOMELLI, *Macchine volanti e strumenti metereologici e di volo in Leonardo da Vinci*, "Annali dei lavori pubblici", XXXIX, Rome 1939.

R. MARCOLONGO, *Il volo degli uccelli e il volo umano o strumentale*, in *Leonardo da Vinci artista-scienziato*, Milan 1939, pp. 253-267.

R. GIACOMELLI, *Contributi all'aeronautica e alla dinamica indebitamente attribuiti a Leonardo da Vinci*, "L'aeronautica", XX, Rome 1940.

C. ROSSI, *Dalla rana di Galvani al volo muscolare*, Milan 1940.

JOTTI DA BADIA POLESINE, *Breve storia dell'aeronautica italiana. 2. Leonardo da Vinci*, Milan 1941.

R. MARCOLONGO, *Leonardo da Vinci artista e scienziato*, Milan 1950, pp. 205-216.

C. ZAMMATTIO, *Gli studi di Leonardo da Vinci sul volo*, "Pirelli", IV, Milan 1951, pp. 16-17.

M. L. BONELLI, *Leonardo e le macchine per volare*, "L'illustrazione scientifica", 4, Milan 1952, 31, pp. 26-28.

V. MARIANI, *Le macchine volanti di Leonardo da Vinci*, "Ciampino: aereoporto internazionale", Rome 1952, IV, 6, pp. 7-15.

R. GIACOMELLI, *Leonardo da Vinci e la macchina di volo*, "Scienza e vita", XLIV, Rome 1952, 42, pp. 395-408.

"Rivista aeronautica", 28, Rome 1952, 3, special issue dedicated to Leonardo (essays by S. Taviani, R. Giacomelli, L. Grosso).

A. UCCELLI (with the collaboration of C. ZAMMATTIO), *I libri del volo di Leonardo da Vinci*, Milan 1952.

C. ZAMMATTIO, *Le ricerche sul volo di Leonardo da Vinci*, "Sapere", 35, Milan 1952, 413-414, pp. 88-91.

M. R. DUGAS, *Léonard de Vinci dans l'histoire de la mécanique*, in *Léonard de Vinci et l'expérience scientifique au XVIᵉ siècle*, Atti del Convegno, Paris 1952, Paris 1953, pp. 88-114, in particular pp. 98-108: *Du vol des oiseaux à la machine volante par la théorie du vol*.

R. GIACOMELLI, *I precursori*, "Rivista aeronautica", II, 12, 1953, pp. 759-800.

P. Magni, *I libri del volo di Leonardo da Vinci* [I, II e III], "Rivista d'ingegneria", 3, 1953, 4, pp. 393-400 [I]; 5, pp. 537-544 [II]; 6, pp. 645-651 [III].

C. Pedretti, *Macchine volanti inedite di Leonardo*, "Ali", 3, Turin 1953, 4, pp. 48-50.

V. Somenzi, *Ricostruzioni delle macchine per il volo*, in AA. VV., *Leonardo. Saggi e Ricerche*, Rome 1954 (1952), pp. 57-66.

C. Pedretti, *Spigolature aeronautiche vinciane*, "Raccolta Vinciana", XVII, Milan 1954, pp. 117-128.

C. Pedretti, *L'elicottero*, in *Studi Vinciani*, Genève 1957, pp. 125-129.

C. Pedretti, *Il foglio 447E degli Uffizi a Firenze*, in *Studi Vinciani*, pp. 211-216.

L. Reti, *Helicopters and whirligigs*, "Raccolta Vinciana", XX, Milan 1964, pp. 331-338.

I. B. Hart, *Artficial flight and the flight of birds*, in *The world of Leonardo da Vinci man of science, engineer and dreamer of flight*, London 1961, pp. 307-339.

Ch. H. Gibbs-Smith, *The Aeroplane: An Historical Survey*, London 1960.

Ch. H. Gibbs-Smith, *A Note on Leonardo's Helicopter Model*, in I. B. Hart, *The World of Leonardo da Vinci*, London 1961, pp. 356-357.

B. Gille, *Les ingénieurs de la Renaissance*, Paris 1964.

M. Cooper, *The Inventions of Leonardo da Vinci*, New York 1965 (in particular *Flight*, pp. 52-61).

Ch. H. Gibbs-Smith, *Leonardo's da Vinci Aeronautics*, London 1967.

Ch. H. Gibbs-Smith, *Léonard de Vinci et l'aéronauthique*, "Bulletin de l'Association Léonard de Vinci", 9, Amboise 1970, pp. 1-9.

E. Petitolo, *Le carnet de vol de Léonard de Vinci*, "Bulletin de l'Association Léonard de Vinci", 11, Amboise 1972, pp. 15-22.

O. Curti, *Leonardo da Vinci e il volo*, "Museoscienza", 15, Milan 1975, 3, pp. 15-25.

G. Dondi, *In margine al codice vinciano della Biblioteca Reale di Torino. Note storico-codicologiche*, "Accademie e Biblioteche d'Italia", XLI-II, 1975, 4, pp. 152-271.

C. Pedretti, *Codice sul volo degli uccelli*, in *Disegni di Leonardo e della sua scuola alla Biblioteca Reale di Torino*, Florence 1975, pp. 41-50.

I. Strazheva, *Leonardo da Vinci and modern flight mechanics*, in *Leonardo nella scienza e nella tecnica*, Proceedings of the international symposium on the history of science (Florence-Vinci 1969), Florence 1975, pp. 105-110.

Léonard de Vinci: l'art du vol, educational exhibition Caen 1978.

B. Dibner, *Leonardo and the third dimension*, in E. Bellone-P. Rossi (edited by), *Leonardo e l'Età della Ragione*, Milan 1982, pp. 79-100 (in particular, pp. 88-94).

C. Pedretti, Introduction to *Leonardo da Vinci, The codex on the flight of birds in the Royal Library at Turin*, ed. by A. Marinoni, traslated from the Italian by D. Fienga, New York 1982 (Florence, Giunti Barbèra).

S. Nosotti (edited by), *Leonardo da Vinci: l'intuizione della natura*, exhibition catalogue (Milan 1983), Florence 1983, pp. 37-56.

C. Hart, *Leonardo's theory of bird flight and his last ornithopters*, in *The prehistory of flight*, Berkeley 1985, pp. 94-115.

P. Galluzzi, *La carrière d'un technologue*, in *Léonard de Vinci ingénieur et architecte*, exhibition catalogue, Montreal 1987, pp. 80-83.

M. Kemp, *Les inventions de la nature e la nature de l'invention*, in *Léonard de Vinci ingénieur et architecte*, exhibition catalogue, Montreal 1987, pp. 138-144.

C. Pedretti, *Il Codice sul volo degli uccelli e i suoi disegni di carattere artistico*, in *I disegni di Leonardo e della sua cerchia nella Biblioteca Reale di Torino*, Florence 1990, Appendix I, pp. 109-114.

G. P. Galdi, *Leonardo's Helicopter and Archimedes' Screw: The Principle of Action and Reaction*, "Achademia Leonardi Vinci", IV, 1991, pp. 193-201.

A. Ellenius, *Ornithological imagery as a source*, in R. G. Mazzolini (edited by) *Non verbal communication in science prior to 1900*, Florence 1993, pp. 375-390 (in particular, pp. 384-386).

M. Pidcock, *The Hang Glider*, "Achademia Leonardi Vinci", VI, Florence 1993, pp. 222-225.

P. Galluzzi, *Leonardo da Vinci: dalle tecniche alla tecnologia*, in *Gli Ingegneri del Rinascimento da Brunelleschi a Leonardo da Vinci*, exhibition catalogue (Florence 1997), Florence 1996, pp. 69-70.

D. Laurenza, *Gli studi leonardiani sul volo. Spunti per una riconsiderazione*, in *Tutte le opere non son per istancarmi. Raccolta di scritti per i settant'anni di Carlo Pedretti*, Rome 1998, pp. 189-202.

D. Laurenza, *Leonardo: le macchine volanti*, in AA. VV., *Le macchine del Rinascimento*, Rome 2000, pp. 145-187.

D. Laurenza (scientific co-ordination and text),

Leonardo. Uomo del Rinascimento Genio del futuro, (5 volumes), Novara 2001-2003.

D. Laurenza, *Leonardo da Vinci. Codice sul volo degli uccelli*, in *Van Eyck, Antonello, Leonardo. Tre capolavori nel Rinascimento*, Turin 2003, pp. 70-73.

Editions on the Codex 'On the Flight of Birds'

I Manoscritti di Leonardo da Vinci. Codice sul volo degli uccelli e varie altre materie. Published by T. Sabachnikoff. Transcriptions and notes by G. Piumati. French translation by C. Ravaisson-Mollien, Paris 1893.

Leonardo da Vinci's Manuscript on the Flight of Birds, English translation by Ivor B. Hart, in "The Journal of the Royal aeronautical Society", XXVII, London 1923, pp. 289-317; Idem, *The Mechanical Investigations of Leonardo da Vinci*, London 1925, Appendix (II ed. Berkeley-Los Angeles 1963, introduction by E. A. Moody).

I fogli mancanti al Codice di Leonardo da Vinci nella Biblioteca Reale di Torino, edited by E. Carusi, Rome 1926.

Il Codice sul volo degli uccelli, edited by S. Piantanida, in *Leonardo da Vinci*, Novara 1939 (2ª ed. 1956).

Leonardo da Vinci, Il Codice sul volo degli uccelli. Facsimile edition of the Codex. Transcriptions and bibliographical annotations by Jotti da Badia Polesine, Milan 1946.

Il Codice sul volo degli uccelli nella biblioteca reale di Torino. Diplomatic and critical transcription by A. Marinoni. Edizione nazionale dei manoscritti e dei disegni di Leonardo da Vinci edited by Commissione Vinciana, Florence 1976.

Leonardo da Vinci, The Codex on the Flight of Birds in the Royal Library at Turin, edited by A. Marinoni; introduction by C. Pedretti; English translation by D. Fienga, New York 1982.

Léonard de Vinci, Le manuscrit sur le vol des oiseaux [dans la] Bibliothèque Royal de Turin; preface by A. Chastel, introduction by A. Marinoni, presentation by S. Bramly, Paris 1989.

Cd-Rom *I Codici multimediali di Leonardo da Vinci. Il Codice sul volo degli uccelli* (transcription by A. Marinoni; presentation and apparatus criticus by D. Laurenza), Anaya Multimedia, Ernst Klett Verlag-Giunti Multimedia, Giunti Gruppo Editoriale, Istituto e Museo di Storia della Scienza di Firenze, Milan and Florence 2000.

PHOTOGRAPHIC REFERENCES

Archivi Alinari, Florence: p. 29
Archivio Giunti/Foto Rabatti & Domingie: pp. 6-7, 8 top, 28 left
Archivio Giunti/Foto Stefano Giraldi: pp. 8 centre right, 17 bottom
Archivio Pubbli Aer Foto/Aerocentro Varesino: p. 33
Atlantide Phototravel, Florence: p. 55 top
Corbis/Contrasto, Milan: p. 85 bottom right
Rabatti & Domingie Photography, Florence: p. 28 bottom right
All the other illustrations are property of Archivio Giunti.

The publisher is willing to settle any royalties that may be owing
for the publication of pictures from unascertained sources.